At Home with Art

French Edition
Editorial Partnerships: Henri Julien and Mathilde Jouret
Editorial and Text Contributions, and Design: Marie Vendittelli
Editor: Virginie Maubourguet

English Edition
Editorial Director: Kate Mascaro
Editor: Helen Adedotun
Cover Design: Audrey Sednaoui
Translation from the French: Elizabeth Heard
Copyediting: Penelope Isaac
Typesetting: Gravemaker+Scott
Proofreading: Nicole Foster

Production: Louisa Hanifi-Morard and Marylou Deserson
Color Separation: IGS-CP, L'Isle d'Espagnac
Printing: Florjancic Tisk, Slovenia

Originally published in French as *Sortons l'art du cadre*
© Flammarion, S.A., Paris, 2021
© Wilo & Grove, Paris 2021

English-language edition
© Flammarion, S.A., Paris, 2022
© Wilo & Grove, Paris 2022

editions.flammarion.com
wilo-grove.com

22 23 24 3 2 1

ISBN: 978-2-08-026134-2

Legal Deposit: 04/2022

**Be wild.
Buy art.**

At Home
with Art

A BEGINNER'S GUIDE
TO COLLECTING ON ANY BUDGET

OLIVIA DE FAYET · FANNY SAULAY

Flammarion

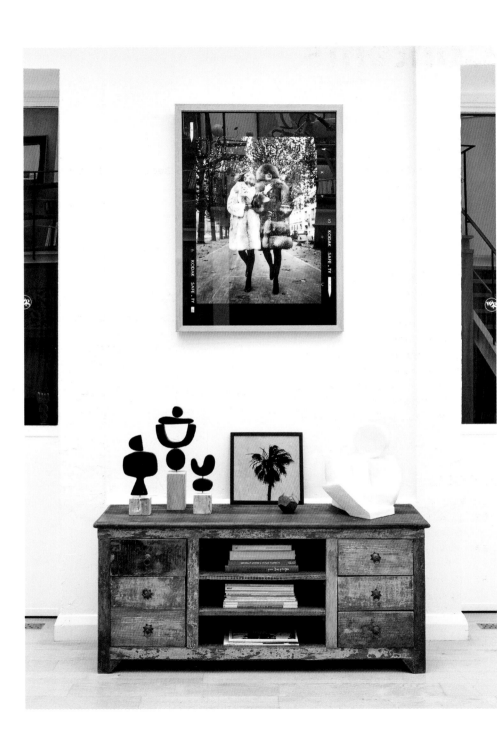

Contents

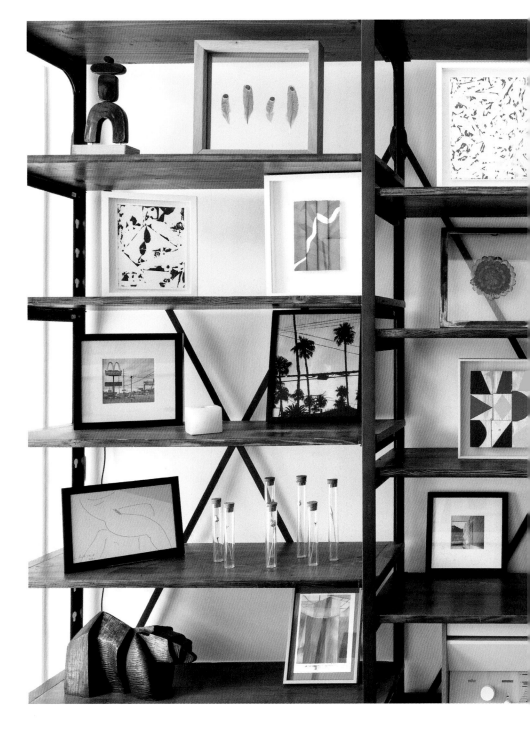

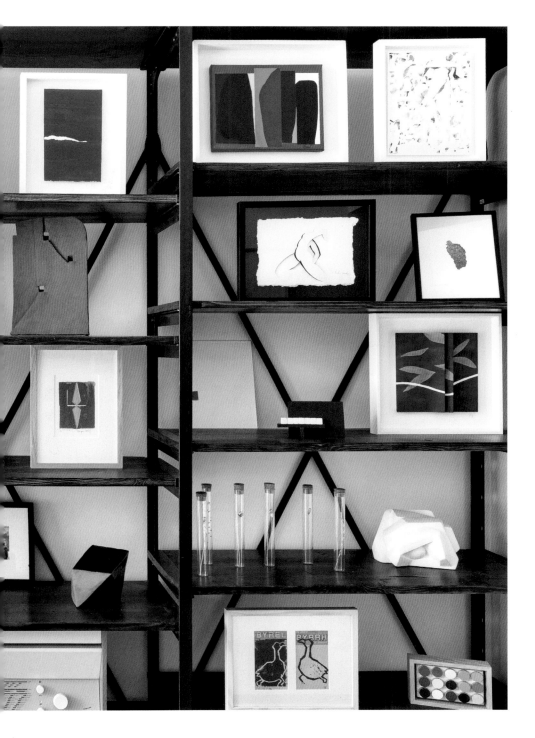

Olivia de Fayet • Fanny Saulay

About Us

Previously, we both worked as modern art specialists at the world's largest auction house, where we met. Then, about a decade ago, we came to the following three conclusions:

1. The art market is wild and uncharted territory for most of us.

2. There is an abundance of artistic talent all around us, just waiting to be discovered.

3. We are experiencing an ever-increasing desire to surround ourselves with objects that have genuine emotional resonance.

So, since none of us has the time to develop a centenarian's wisdom, and since you don't need to be a billionaire to acquire works of art, yield to the temptation! In this book, we will provide you with all the expert advice you need.

Why we wrote this book for you

Through our encounters with the neophyte collectors we've met since establishing Wilo & Grove, we have realized that many of the same questions and concerns come up time and again. This is what inspired and motivated us to gather our expert knowledge, insights, and tips into a useful, handy guide to help you welcome art into your life.

This book is *the* essential reference for all those who wish to surround themselves with works of art and have always wondered how to go about starting a collection.

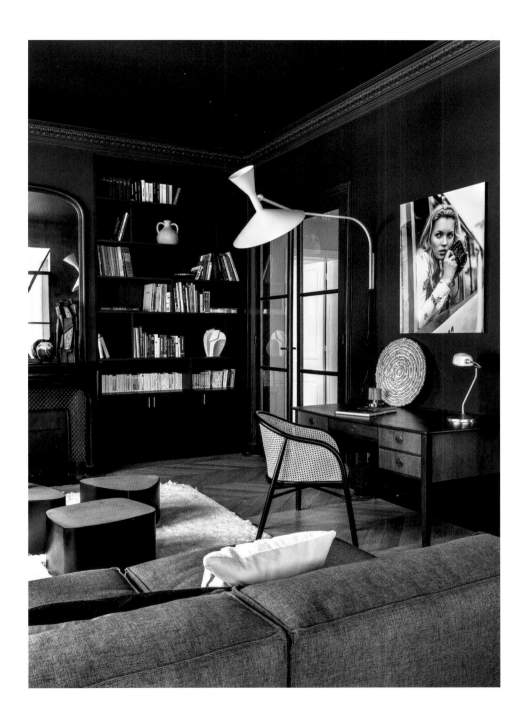

BE AWARE

BE AWARE

Art and the Art Market

The art market can be seen as an exchange where professionals and individuals buy and sell artistic creations. Although this definition is accurate up to a point, it represents only a tiny part of the larger reality, because the participants and types of transactions in the market are multifarious. Art sales occur in a system that is often straightforward, sometimes complicated, but always fascinating. You'll soon see what we mean!

What exactly is a work of art?

A concept that can be difficult to define

A work of art is an aesthetic creation. That is fine as far as it goes, but artworks sometimes unleash passions and emotions that cannot be summarized so briefly and simplistically. In fact, if there is any realm of human activity where subjectivity dominates, it is surely here.

1. A work of art expresses the vision of an artist who, depending on the situation, may wish to leave a mark upon the contemporary art world, carry out exhaustive formal exploration, or even convey a political message. A work of art may also provide an experience of catharsis for both the artist and the audience.

2. Many artworks are unique, but multiplicity is inherent in certain media. Photographs, engravings, and sometimes sculptures are executed in limited editions. Each category is regulated by specific rules that define the number of authorized copies allowing a work to earn the status of an artistic edition.

3. It is not the time expended or complexity that makes a work of art. What really matters is that an artist presents a unique form of expression, an original idea, using a personal, identifiable technique. This distinguishes the artist from the artisan, and explains why forgers are not considered artists in their own right.

A BIT OF HISTORY

According to Hegel, "In brief, art intentionally creates images and appearances that are intended to represent ideas, showing us truth in perceptible forms. In so doing, it has the power to move the very depths of our soul and cause it to experience the pure sense of joy that arises from the sight and contemplation of the beautiful."

The Bigger Picture

In 1917, the French painter Marcel Duchamp presented a porcelain urinal at the Society of Independent Artists' exhibition in New York. He hand-signed it with a pseudonym ("R. Mutt," based on the name of the object's manufacturer) and titled it Fountain. *This type of work is known as a "readymade." The only contribution by the artist was the signature written in his hand. This exercise in bravado, which inaugurated a new "readymade" artistic movement, is regarded as the founding work of contemporary art.*

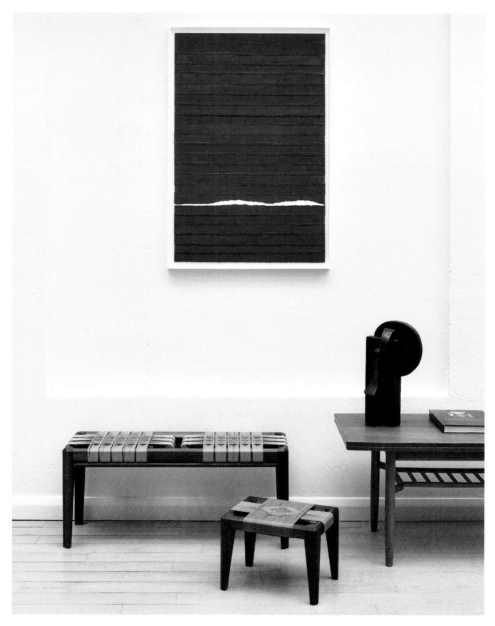

Artists face the perpetual challenge of creating a recognizable and coherent view of the world as well as their own visual signature, while at the same time reinventing themselves throughout their career. Exploring new techniques can help to accomplish this quest.

Various families of artworks

A broad range

Artistic creation knows no bounds. However, it is common to classify works according to the technique used to create them, to help us orient ourselves. There may be a traditional hierarchy in the market among the various categories, but each of them deserves a moment of our attention.

1. All of the following categories have a legitimate claim to membership in the grand family of the arts. The "fine arts" comprise the entire range of artistic disciplines, including painting, sculpture, drawing, and engraving, as well as architecture, music, poetry, theater, and dance.

2. The term "visual arts" applies to two- or three-dimensional works that are created using a tangible material, which is transformed by the artist. This allows them to give physical form to an abstract idea, as opposed to other art forms such as literature, music, or dance, which remain impalpable.

3. A work of art is not intended solely for contemplation—it may also serve a useful purpose. The domain of decorative arts and design combines aesthetic and practical functions. The term "applied arts" is also used.

A BIT OF HISTORY

"Museum" comes from the Greek *mouseion*, which refers to a temple consecrated to the muses, the goddesses of the arts. The concept of the museum as we know it today originated in the Italian Renaissance of the fifteenth century. Credit goes to Cosimo de' Medici, who exhibited his collections in Florence to impress a wealthy audience.

A Word of **Advice** from Fanny & Olivia

The concept of a "work of art" is so vast that we may legitimately wonder if there really is any connection between a classical statue and a contemporary photograph. The simplest way to relate them to each other is not by discussing techniques or aesthetics; instead, consider the emotion generated by the work. If your senses are awakened when standing before an artwork, whatever it may be, you can reasonably conclude that it's a genuine work of art.

1. Painting. This is the top-billed medium, and the oldest (think of those prehistoric cave paintings), and is often considered the noblest. Applied on a wide range of supports (canvas, paper, wood, etc.), pigments offer a vast palette once combined with various binders: water is used for gouache and watercolor, oil for oil paintings, resin for acrylics, and egg yolk for tempera.

2. Drawing. Less highly priced than paintings (paper is cheaper than canvas), drawings were formerly carried out primarily as preparatory studies for paintings. Some contemporary artists work only on paper, with ink or pencil. Drawing is more spontaneous and closer to the creator's hand, expressing the intimacy of the work and highlighting the artistic gesture, emphasizing line over color.

3. Collage. This technique appeared in the twentieth century. It features the use of an infinite variety of novel materials, arranged in abstract or figurative compositions.

4. Ceramics. This is among the oldest artistic techniques, named for Kerameikos, the Athenian neighborhood where potters and tile-makers plied their trades. Fashioned from malleable materials such as clay and fired at high temperatures, these were originally utilitarian objects, including stoneware, earthenware, and porcelain. Ceramics has developed into an artistic discipline in its own right, requiring complete technical mastery.

5. Sculpture. A sculptural work may be carved directly from stone using a chisel to cut away masses—thereby creating a unique work—or modeled from clay by hand or with tools. The latter technique allows a foundry to make a mold that can be used to produce casts in plaster or, more commonly, in bronze. Artistic sculptural editions cannot exceed eight numbered copies plus four artist's proofs (see Glossary p. 128).

6. Photography. Invented in 1826, photography came of age about a century later. Digital photography has now replaced film, but the paper print remains the genre's material actualization and finished product. The photographer and the collector must therefore pay close attention to the quality of the prints, the number of which should be limited to thirty.

7. Engraving. This is the creation of a shape, a line, a drawing, or a pattern incised onto a support using tools. The support— usually wood, metal, or linoleum—is covered with ink in order to transfer the drawing onto paper, either directly by hand or using a press operated by the artist. This practice produces original works in limited numbered editions.

A BIT OF HISTORY The traditional hierarchy of painting genres (1. history; 2. portraiture; 3. genre scenes; 4. landscape; and 5. nature) established in the seventeenth century was toppled by the impressionists in the mid-nineteenth century. They placed landscape at the summit. Meanwhile, the rise of photography upended the concept of painting as a mirror of reality, obliging painters to reinvent their calling. Following in the footsteps of the impressionists, all the major artistic movements of the early twentieth century, led by abstraction and surrealism, have risen to the challenge.

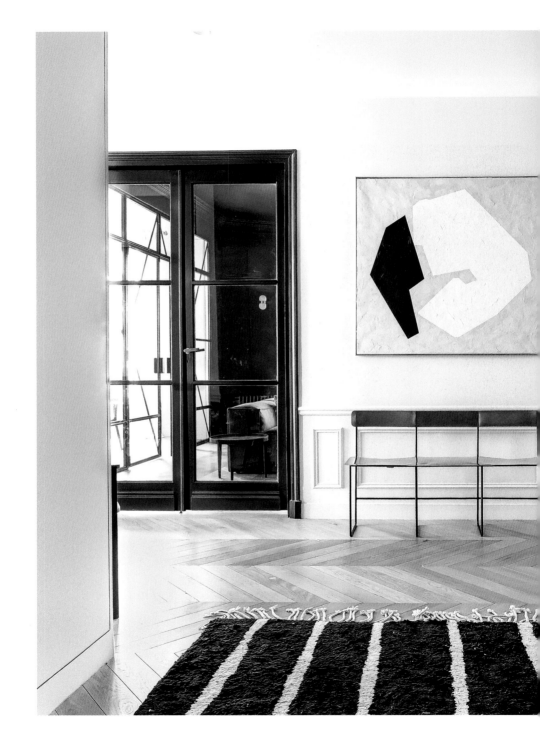

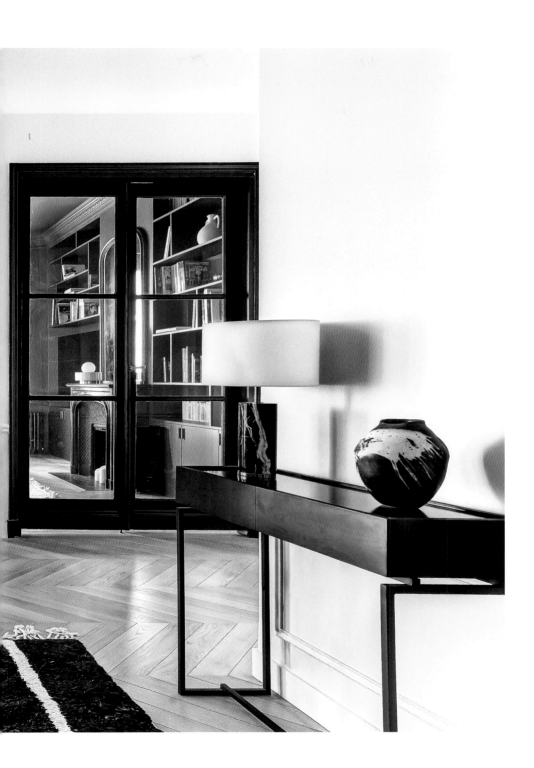

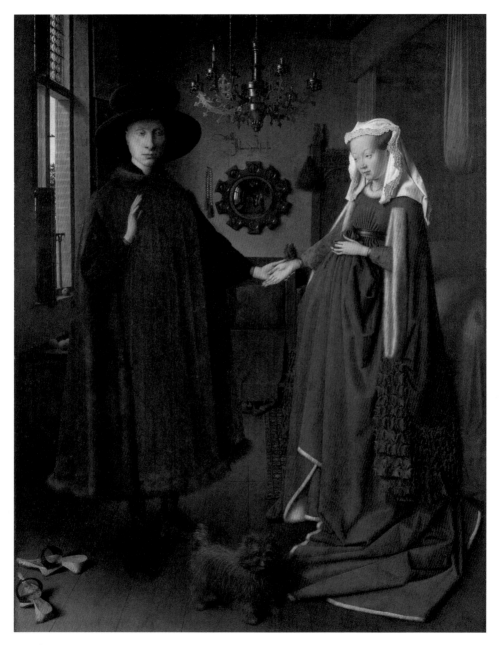

This famous work was painted in 1434 by the Flemish artist Jan Van Eyck (c. 1390–1441). Known as The Arnolfini Portrait, *it depicts Giovanni Arnolfini, one of the era's foremost dealers in precious objects.*

Art transactions since the fifteenth century

In constant evolution

Originally highly confidential in its dealings, the art market has continually developed over time. The way we buy and sell art today is very different from the earliest transactions and involves numerous participants.

1. It is believed that the earliest sales of paintings occurred around 1400 in Florence, Italy and Brugge, Belgium. The most common transaction at the time was the commissioning of an artist by a wealthy patron to execute a specific order; payment was made upon delivery of the work.

2. As time went on, sales developed through dealer transactions and via salons where artists exhibited their own works. These sales sometimes resulted in commissions from wealthy collectors. The number of exhibition venues gradually increased.

3. During the seventeenth and eighteenth centuries, art auctions flourished, particularly in Paris, where most such transactions took place. Currently, artworks are sold worldwide, in auctions but also in galleries, fairs, and, in recent years, via the internet.

A BIT OF HISTORY

The art market has experienced unprecedented growth in the last fifty years, particularly in the last decade, which has witnessed the sale of the ten most expensive works ever sold, including Jackson Pollock's *Number 17A* for $200 million, Paul Cézanne's *The Card Players* for $250 million, and Leonardo da Vinci's *Salvator Mundi* for $450 million.

The Bigger Picture

What is an artist's value? At what point can we say an artist has an established rating? The point of reference remains the price of an artwork at auction, which demonstrates and officially fixes the value of an artist's work at a given point in time. Auction sales—in contrast with gallery transactions, whose details remain confidential—are said to be "public" because the prices are made available to everyone. Galleries play an essential role in establishing the basis for evaluating the worth of an emerging artist.

Why are prices so different?

The law of supply and demand

Prices usually reflect the balance between supply and demand. The price of an artist's work will inevitably increase with sustained demand. However, if the pricing has not yet been clearly established by the mechanisms of the market, a number of fairly logical criteria allow us to assess the fair price of a work of art.

1. The raw materials. The price of a work reflects the cost of the materials used to create it.

2. The technique and format. The more a work demonstrates mastery of a technique and artistic skill, the more valuable it will be. If created using the same technique, a small piece will—logically enough—cost less than a larger version.

3. The artist's career. When artists have been known and recognized for several years, and have existing sales to their credit, these prices will serve as a point of reference: a snapshot of the value of their work. Their training and exhibition history will also be considered when establishing the price of their work.

4. The time taken to create the work. This is not always obvious at first glance, but it should be considered. A lengthier time implies a lower rate of production, since the artist's output is necessarily limited by the time available. However, the time spent on the actual execution of the work is only the tip of the iceberg. The duration of the conceptualization phase is also a determining factor, although it is much more difficult to measure as the process can sometimes take artists far back in time, to the source of their inspiration and the beginning of their explorations.

5. A professional's eye. Assessment of a work's value also depends on the expertise and eye of a specialist who knows how to evaluate the artistic and commercial value of an artwork, beyond its tangible, quantifiable parameters. If you are a little baffled, don't hesitate to ask a professional for help to get a better understanding.

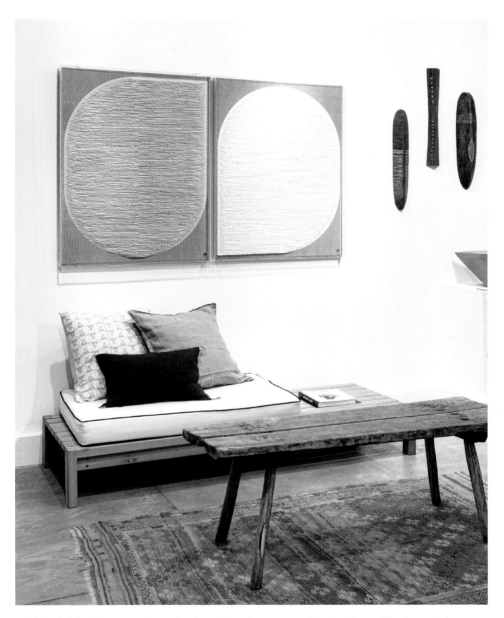

Highly visible figures such as the American investment banker Leon Black and his wife Debra, or French businessman François Pinault (among the ten most influential art collectors in the world) can raise the prices of certain works and the reputation of their creators to dizzying heights. These extraordinary transactions remain the rare exception, but they have a lasting and significant impact on the art market, primarily for contemporary artworks.

BE AWARE

The Market Players

Now you know how to classify a work, and have learned various ways to establish its value, it's time to discover how to acquire artworks on the most favorable terms possible. Here, we unveil the secrets of an ecosystem that can seem somewhat obscure to newcomers.

Who's allowed to sell art?

Everyone, but not in the same way

The sale of artworks is subject to strict regulations. This is why we recommend that you rely on knowledgeable professionals who are fully cognizant of the law. Auction houses and recognized galleries insure that your transaction is entirely secure. Be vigilant when dealing with other sellers.

1. Auction house specialists. Major auction houses are authorized experts in appraising and selling works of art (see also pp. 33–35).

2. Art galleries. Whether they operate out of well-established street locations or sell online, they are authorized to execute transactions while acting in conformity with specific standards and criteria (see p. 37).

3. Specialized marketplaces. There are numerous sites selling artworks. The range of choice is vast, but provenances of the works are sometimes difficult to determine. Assistance is limited, and these platforms may be less appropriate for buyers who are starting out.

4. Individuals. They may sell their work via a website or at salons and fairs, but they are required to declare their revenues to tax authorities.

DID YOU KNOW?

We refer to the "primary market" when artists sell their own works or offer them for sale through an intermediary. When a work passes from the original purchaser to another buyer, we refer to a "secondary market," in which auction houses and non-contemporary art galleries participate.

A Word of **Advice** from Fanny & Olivia

Art sales are generally organized by categories (ancient art, contemporary art, etc.). To avoid unpleasant surprises and get reliable advice, it is best to approach specialists in the area of your choice. The art market is also subject to fiscal regulations, and each country has its particular laws; taxes such as VAT will vary, and certain countries have strict rules concerning the exportation of artworks. It is important to be aware of the specific regulations in the country in which the art sale is taking place, so you have a good idea of the total cost and the legal implications.

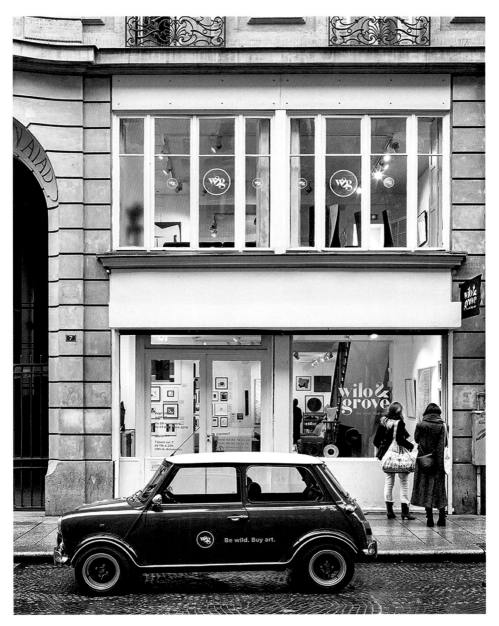

Galleries may at first seem rather intimidating, but they offer the most direct access to works that have been selected by a professional. Don't hesitate to venture inside if a work within appeals to you—they are there to be enjoyed by everyone.

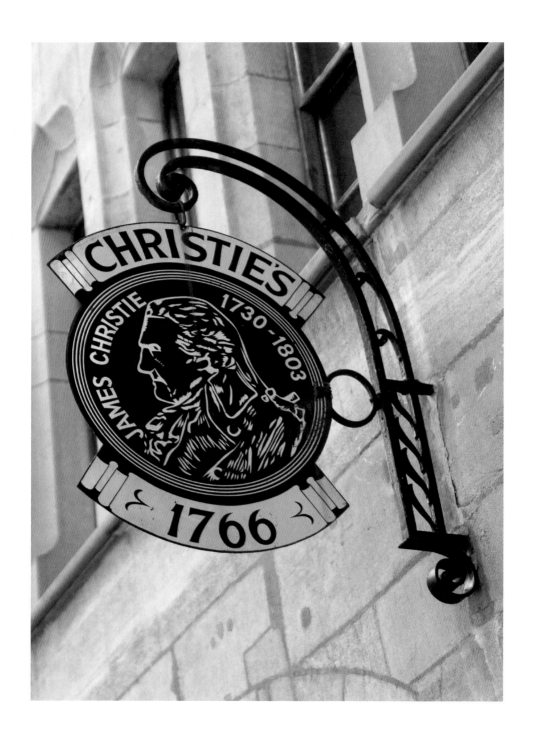

Auction houses | Across the world

A BIT OF HISTORY

In the seventeenth century, auction sales were primarily used to dispose of works that were unsold at fairs, to save the cost of transporting them home. The practice rapidly developed into a means for selling all types of works, particularly in Paris, which, in the late eighteenth century, became the most significant art market in the world. Today, an institution such as Drouot in Paris, which comprises sixty auction houses, puts some four hundred thousand objects up for sale annually. In 2020, auction houses across the globe were responsible for the sale of almost eight hundred thousand artworks and objects.

The Bigger Picture

A "lot" is a work or group of works sold at auction under the same number. A single sale may consist of several hundred lots. It is rare for all of the lots in an auction to find a buyer. When this unusual event occurs, it is called a "white glove" sale, because white gloves were traditionally presented to the triumphant auctioneer to honor their outstanding performance.

While various authorities (such as customs) organize auction sales following property seizures (referred to as "court-ordered sales"), paintings and valuable objects account for a negligible share of such transactions. The finest pieces are sold by the major auction houses.

1. Christie's and Sotheby's, both founded in London in the eighteenth century, are the oldest and most prestigious auction houses in the world. Together with Phillips, they account for 70 percent of auction sales and 10 percent of lots sold by volume. Heritage Auctions, based in Dallas, Texas was founded more than two centuries later, but is now the world's largest "collectibles" auctioneer. Chinese auction houses have experienced explosive growth over the last twenty years, occupying all the other spots in the top ten listing, Beijing Poly International Auction being the largest.

2. The auction house offering the artworks does not own them at any point. The firm acts under the mandate of the seller and receives a commission for its services as intermediary with the buyer, paid only if the object is sold.

3. Given the sizable amounts of the sums in question, competition is fierce. The auction house that snares the most prestigious collection or work earns the admiration and envy of competitors.

What happens during an auction?

A Word of **Advice** from Fanny & Olivia

If you are interested in purchasing at an auction, take the time to study the catalogs or visit the site to view the objects and their condition. If you can't go in person, request additional photographs and the condition report. Figure out which pieces you've really fallen for, whose pricing seems to you to be affordable, then set yourself a budget that is not to be exceeded. And don't forget the "buyer's premium," which can range from 15 to 30 percent depending on the auction house. This amount will be added to the final sale price and can significantly increase the bill.

DID YOU KNOW?

The French system for protecting its national heritage is unique. Museums and other entities have a so-called "preemptive right" to works that can be exercised at public auctions. They can claim ownership at the market price, substituting themselves for the last and highest bidder to that buyer's detriment. When the lot is pronounced "sold" by the auctioneer, the museum's representative must be physically present in the room, stand up, and announce the preemption.

The countdown begins. . . .

Stress, adrenaline, euphoria, disappointment: an auction can easily become an emotional roller coaster for the participant.

1. At least one day before the auction, the objects for sale are publicly exhibited. This allows you to study them, assess their condition, colors, and scale, and perhaps realize that you have fallen in love. The auctioneer is frequently in attendance, and it's a good opportunity to glean some additional information.

2. On the day of the sale, all the objects are presented, along with an indication of their estimated price. A reserve price, beneath which the work will not be sold, is established with the seller and remains confidential. To participate in the sale if you are present in the room, simply raise your hand to indicate that you wish to bid. The auctioneer must observe the minimum bidding increments, which may change based on the bidding activity. Typical increments are, for instance, $200 between $2,000 and $3,000, or $10,000 between $100,000 and $200,000. Similar increments are used for other currencies. You can also choose to bid by leaving a written order for a maximum amount that you specify in advance, or bid remotely by phone or online.

3. **When there are no further bids**, the auctioneer bangs his hammer and pronounces the word "sold." The sale is set definitively at the so-called "hammer price," to which is added the "buyer's premium." But a note of caution: there is no cooling-off period for the purchase, and you must make immediate payment, subject to penalties and additional charges.

It's said that the Roman consul Lucius Mummius held the first auction in 146 BCE to sell off treasures stolen from the Greeks. This type of transaction became increasingly common over the centuries and was extended to artworks in the eighteenth century. Today, thanks to the digitalization of auctions, sales can now be made online, with bidders participating from all over the globe—a practice that has frequently been used by large houses such as Sotheby's and Christie's to sell rare pieces to the international market.

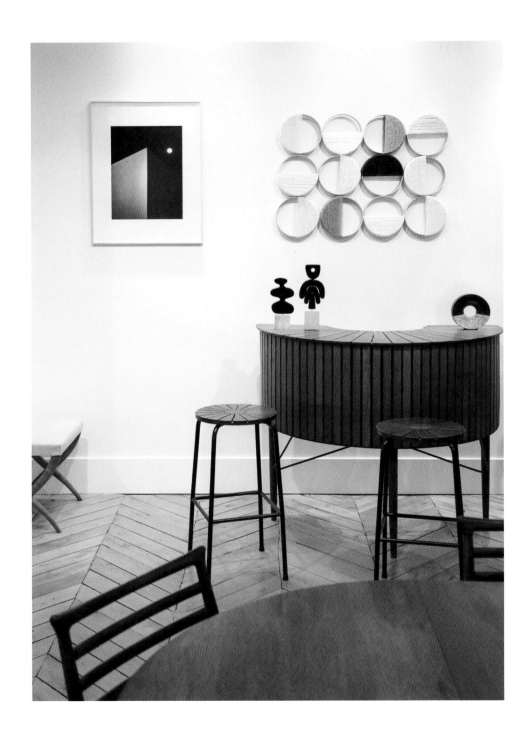

Independent galleries

A focus on contemporary galleries

A BIT OF HISTORY

The first art galleries appeared in the late nineteenth century. Until that time, works of art were only exhibited in salons, which limited the number of potential buyers.

The Bigger Picture

A gallery's task also entails assisting artists in the creative process. We're there to help with commercial issues, including working together to establish fair prices, but we may also be called upon to participate in their artistic reflection—should a certain technique be explored in greater depth, or a certain series taken further?—based on our personal convictions as well as the invaluable feedback we receive from clients.

DID YOU KNOW?

A gallery pays its artists directly. It regularly submits a statement summarizing sales, followed by the corresponding bank transfer payment.

A distinctive feature of contemporary art galleries is their direct contact with artists and their closeness to the creative process.

1. Contracts. There is a genuinely trusting relationship between galleries and the artists they represent, but they make contractual commitments to each other to solidify this association. With rare exceptions, artists consign their works to the gallery, which does not own them. The gallery earns a commission in the event of a sale, usually ranging between 40 and 50 percent, which may seem excessive, but a gallery's expenses (rent, marketing, insurance, staff, etc.) are very high.

2. Promotion. The gallery's objective is to convey to each visitor its enthusiasm for the artists it represents and to champion their work. This mission is accomplished through an attractive display of the artworks in high-quality exhibition spaces, striking visual support (photographs and videos), and clear, targeted communication (newsletters, informative texts, social networking, etc.).

3. Sales. The gallery manages the commercial side of the art deals. It also handles prospecting, negotiations, the closing of a sale, and administrative tasks (billing, packaging, transport, after-sales service).

Other channels

The choice is yours

A Word of **Advice** from Fanny & Olivia

Don't hesitate to ask for a test installation of a work in your own home, based on a photograph of the intended setting. Look out for galleries or websites that present their artworks in context, as we do, in order to make it easy for you to envision them in your home, and to give you an idea of their scale and impact in an actual room.

DID YOU KNOW?

Today, certain modern galleries, such as Wilo & Grove, are reinventing the traditional gallery model to offer visitors an experience tailored to their needs or desires. You can select an individual appointment, wander at will in the shop, browse and purchase online, or make discoveries in unexpected venues courtesy of the gallery's partners. There's an option to suit everyone.

1. Major art fairs. Prices are often high, but fairs are a good opportunity to train your eye, if not to buy. Taking place all over the world, these exhibitions are well worth a visit: consider The Armory Show in New York, the Frieze London art fair, the FIAC show in Paris, or the Art Basel fairs.

2. Internet. The options are numerous, including online marketplaces, gallery stores, and auctions, which can all be a little disconcerting. But they offer a useful reconnaissance or purchasing tool for those who are not able or prefer not to shop in person. You can request additional photographs and information, videos, or videoconferences to get a better understanding of the works. Purchasing online requires the same degree of vigilance as for any internet transaction.

3. The artist. It is always possible to knock directly on the artist's door, especially on an open studio day. A meeting with the artist is a special moment and an opportunity to discover a new talent. Be aware, however, that an artist represented by a gallery will charge the same prices as the gallery does, and quite often they will just refer you back to whichever gallery has been assigned to handle negotiations on their behalf. Also, if you choose to deal directly with an artist, you won't benefit from the advice and experience that an art-world professional can offer.

The relationship between artists, gallerists, and collectors

The delicate balance in the primary market

To make a work of art, you need an artist! They are the first player in a chain of events that continues with the gallerist and culminates with the collector. It's a virtuous triangle, in which every participant should benefit.

1. The artist. No artist means no artwork—and no art market. The artist's profession entails a long creative process to attain the goal of artistic production. It requires research, inspiration, experimentation, and perpetual reinvention and self-questioning. It's a full-time job.

2. The gallery. Its role is to spot the talent of artists, assess the market value of their works, and promote their oeuvre. It is also there to advise and assist collectors who may be more or less knowledgeable. The gallerist thus bridges the sometimes gaping divide between two worlds.

3. The collector. The value of a work is not established until it is purchased: the buyer makes the price. Through their acquisitions, collectors discover the joys of falling in love with an artwork, revealed afresh each day. They also act, indirectly, as patrons by supporting the artist's creation.

DID YOU KNOW?

The association between an artist and a gallery is first and foremost a human adventure that extends beyond a mere business relationship. By submitting a work, an artist entrusts a part of their soul, and this is no trivial undertaking. From then on, the gallery is responsible for promoting the artist's work and accompanying them on their career path.

The Bigger Picture

The cornerstone of a gallery's work is to establish a price that is fair to all. Artists must be satisfied with their share so that they can pursue their artistic creation with a sense of security. Gallerists, who assume high operating and promotional expenses, have to ensure the sustainability of their business. Collectors must be assured of the quality of the artwork in relation to the sum invested.

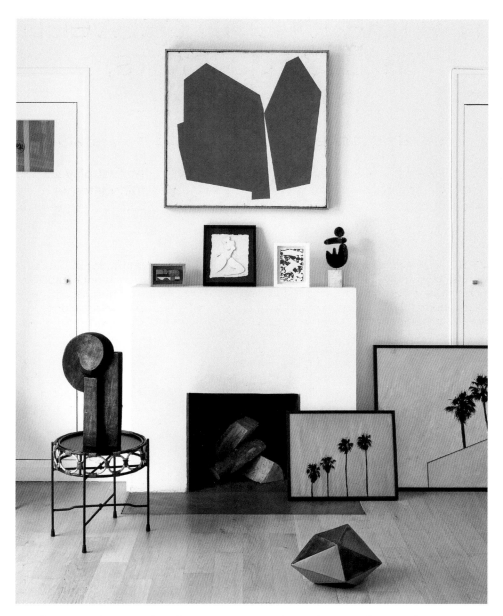

A gallery may choose to show just one artist at a time, whereas others, such as Wilo & Grove, prefer to opt for group exhibitions. These provide an opportunity for numerous artists to exhibit at the same time, and offer visitors a varied selection. It's also advantageous for buyers, who can visualize the potential combinations of works and the infinite array of harmonious arrangements.

How does a gallery choose an artist?

On the basis of emotion—but that's not all

Have you ever tried to explain exactly why you are drawn to a painting? It's not always easy. For a gallerist, it is the same, except that their more experienced eye is likely to be able to recognize the true artistic quality of a work. Nevertheless, it remains quite a subjective choice.

1. Love at first sight. It's tricky to explain why we fall in love! We sometimes say that a work "speaks" to us when it creates an immediate connection. This is a perfectly valid criterion. And if there's also a connection with the artist, the gallerist can be pretty sure that there is potential for a fruitful collaboration.

2. Using a good eye. Beyond their spontaneous emotional responses, gallerists will study the work to assess its quality. They consider the workmanship, mastery of the technique used, whether the quality of the materials is up to standard, if there is genuine creativity, if the artist will be sufficiently prolific in order to respond to continuing demand—in short, whether the gallery will be able to sell the artist's work over the long term.

3. The price range. Gallerists know their buyers, and they seek out artists whose prices are suited to their clientele.

DID YOU KNOW?

There is an incentive from both the gallerist's and the artist's point of view to maintain a harmonious and transparent relationship. In this way, the dealer will be more engaged and committed to selling the works, and this enthusiasm and commitment will in turn fuel the artist's creativity.

The Bigger Picture

Artists must fit into a gallery's profile, but they must also differentiate themselves from the other artists represented there. They need to complement one another through their distinctiveness and originality, and the works must never detract from each other in any way. We gallerists have to be vigilant in maintaining this balance.

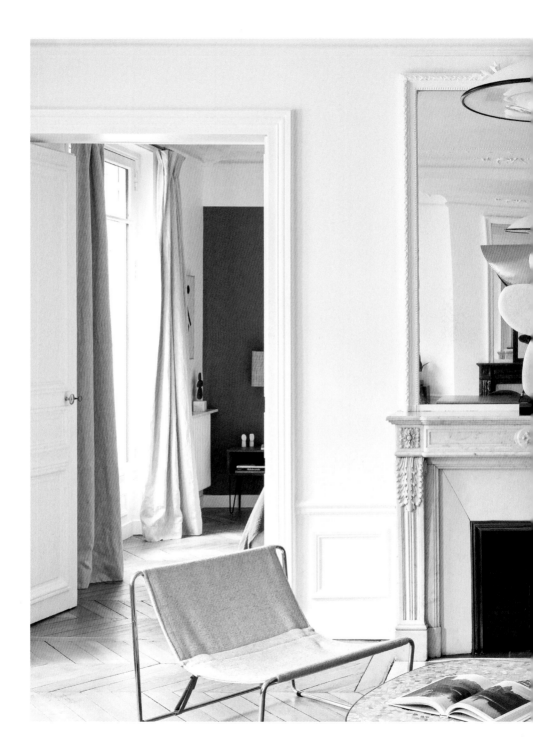

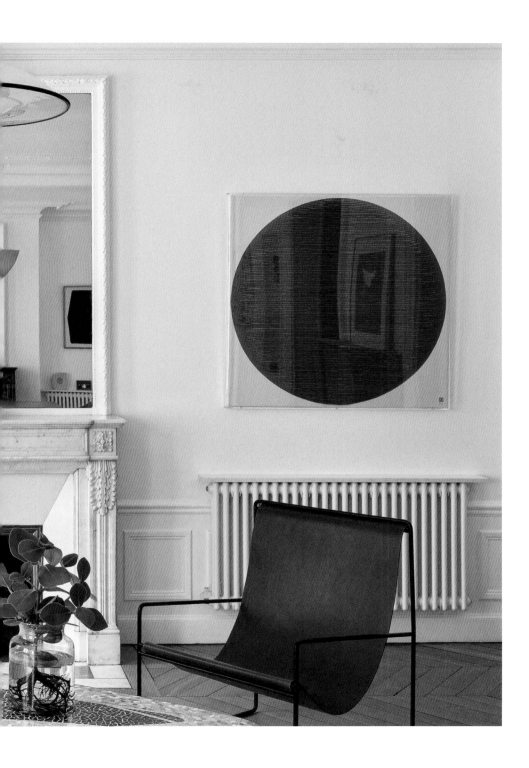

What if you're an artist yourself?

DID YOU KNOW?

Some meetings can change the entire trajectory of a career. The first encounter between an artist and their gallery is one such event. Since time immemorial, behind every great artist has stood a great art dealer.

A Word of **Advice** from Fanny & Olivia

If you really want to be noticed, it's best to aim for originality and avoid being imitative. Above all, don't take offense at any critical comments. On the contrary, try to understand why a work that you're so proud of doesn't meet with universal approval from professionals. Recognize that gallerists also need to earn a living. They choose artists based on their clientele's preferences and not solely on their own personal tastes.

How to sell your work

You may have been refining your artistic technique for months, or even years. You realize that your work has distinctive qualities and you receive regular compliments from admirers. Perhaps a great artist is lying dormant within you. So, where can you find the most receptive audience for your masterpieces?

1. Galleries. It is essential to show your work to a professional. Make a list of galleries that show artists whose approach bears some resemblance to yours. Compile a portfolio, gathering photographs of your best work. If the gallerist is interested, you will be contacted for additional information.

2. On the Internet. Online sales sites and social networks have truly revolutionized the sale of artworks. Instagram now seems to be one of the best ways of getting an audience for your work. But it's essential that an Instagram account be frequently and copiously updated; you must constantly display new work, which requires significant artistic output. Wait until you've amassed a mini-collection before launching your account. You can also create a sales site in your own name or sell via specialized platforms.

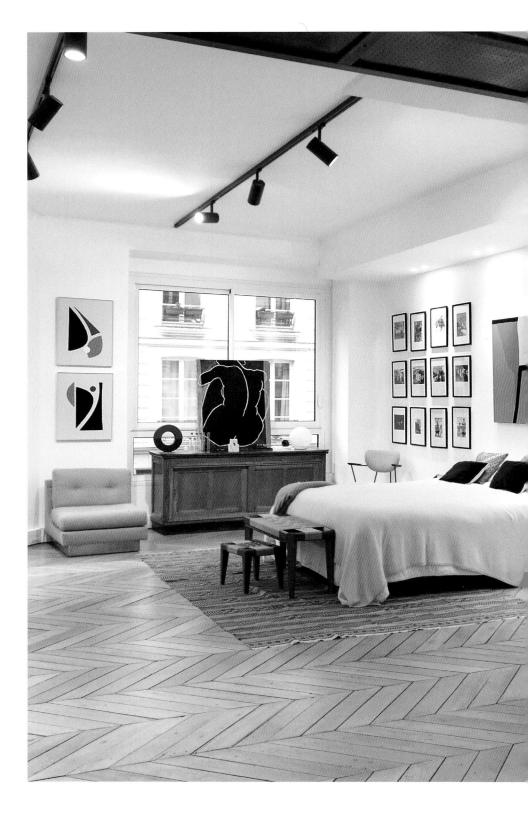

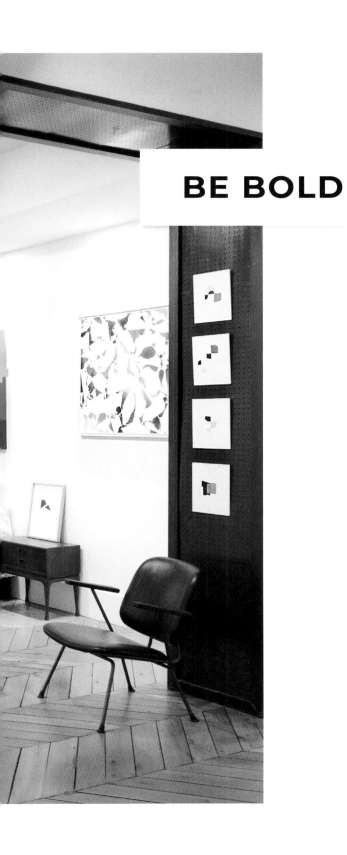

BE BOLD

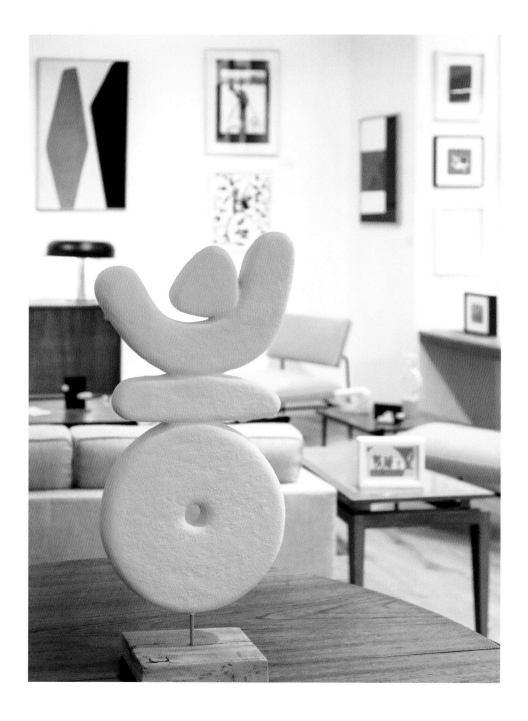

BE BOLD

Take the Plunge: Buy Art!

Why spend your money on yet another pair of sneakers when for the same price (or nearly) you can buy an artwork or object that will last, and will brighten up your daily existence to boot? If you haven't yet decided to make art part of your life, here are all the reasons to make the leap.

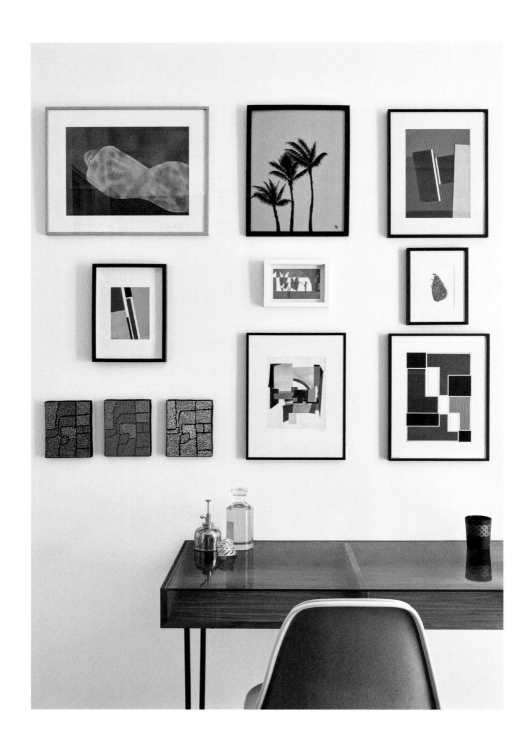

A thousand and one good reasons to get started

Why buy art?

You just can't endure living with that huge empty wall any longer, or you can't bear that dreary poster that you've looked at a thousand times, with its yellowing edges. Maybe you feel a tinge of envy as friends proudly show off their latest acquisition? Are you beginning to visit artwork sale sites? It sounds as if you're ready.

1. You can express your personality in your interior decor with no inhibitions, so take advantage of this opportunity to stand out. Through art, you can turn your home into a place that is one of a kind and perfectly reflects you.

2. There's been a frenzy of mass-market consumption in recent decades. Now our purchasing preferences are naturally shifting toward objects that have a meaning—a unique history that relates to our own experience. A work of art fits seamlessly into this contemporary dynamic: it is a timeless object of devotion that we'll own for a lifetime and perhaps pass on to future generations.

3. Purchasing art also indirectly finances the work of artists. The income allows them to pursue their vocation and thus refine their style. For any future patron of the arts, this is yet another motivation, if one is needed.

PROFESSIONAL POINTERS

It is increasingly common to club together for a joint gift for weddings, birthdays, and other special occasions, with everyone trying to come up with the perfect gift idea. Why not consider giving a work of art? An artwork is a uniquely thoughtful present that lasts a lifetime.

A Word of **Advice** from Fanny & Olivia

No more bland conformity in our interiors! Our homes have become havens where we spend more and more of our time. It's natural to want to make them into refuges where we feel completely at ease. We often think about decor and furnishings, but art is really the finishing touch that gives soul to a living space.

What are the most frequent hurdles?

PROFESSIONAL POINTERS

Go to museum art shows. Since purchasing the works is out of the question, you can gradually define and refine your artistic taste by contemplating works of various periods and styles, without being influenced by prices or trends.

A Word of **Advice** from Fanny & Olivia

We haven't always been art experts; we have just had a bit of a head start on our clients because we have been moving in these circles for quite a few years. We, too, have fallen in love with pieces we could never afford for ourselves. That's why, at Wilo & Grove, we made a conscious decision to promote artists whose work remains affordable. It's our way of allowing everyone to satisfy their desires without spending excessively. Look out for contemporary galleries that cater to all budgets.

The preconceived ideas to drop

The art world can appear daunting and intimidating, seemingly reserved for an elite clientele. But here are a few notions you should strike from your mind.

1. "I don't know anything about art." You don't have to be Mozart to be moved by a symphony. We all have our own artistic sensibilities—we just have to learn how to pay attention and embrace these feelings. In other words, trust your instincts. People aren't born art lovers: we've all been training our eye, bit by bit, for our entire life, without even realizing it.

2. "It's bound to be too expensive." Prices are often available only upon request, which gives rise to the fear of inflated amounts quoted on a case-by-case basis. Furthermore, the most publicized artworks in museums, auction sales, and major fairs are the highest-priced, which compounds this erroneous impression. Even though everything is relative and the outlay may be significant, the vast majority of artists create affordable works.

3. "I don't know where to start." The abundance of works for sale and the various physical and online sales platforms can make your head spin. Word-of-mouth advice is often the best gauge of quality. But the most important thing is to take your time, persevere, and indulge your curiosity.

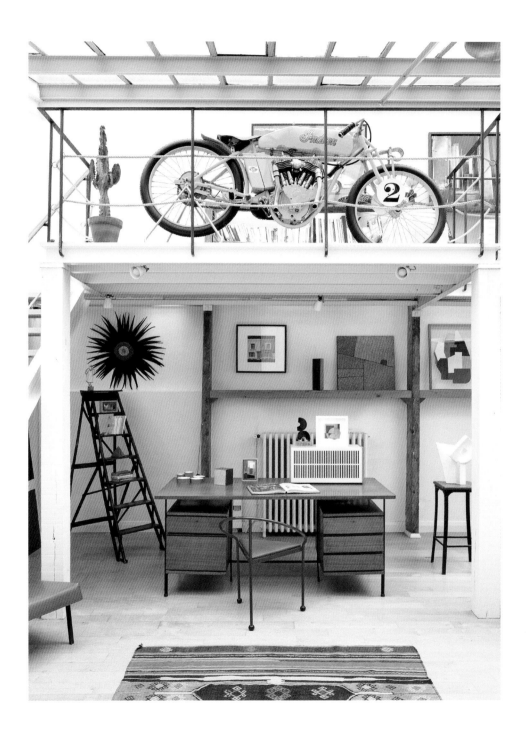

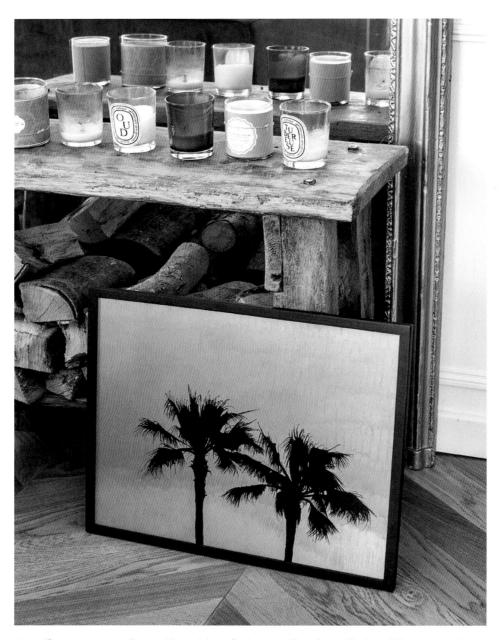

Even if you enter a gallery with no idea of what you like, the gallerist will be attuned to your cues and will gladly point you in the right direction.

It's time to ask yourself the right questions

How to lay the groundwork

Purchasing a work of art is an important decision. It represents a significant financial outlay, and it's a choice you make for the long term. While it is possible to buy on an impulse and never regret it, it is still advisable to pause for a moment's reflection.

1. Establish a maximum budget upfront to fix your intentions and establish the range of possibilities. This will also prevent needless frustration or regret in case you're stricken by a case of love at first sight.

2. Identify and measure the spot where you plan to display the work. A painting will appear smaller in a large empty space with a lofty ceiling than in an average-size living room. To avoid disappointment, the gallery can prepare a simulation on a photograph of your interior so you can get a sense of the proportions of the work on your wall.

3. Choose carefully when selecting the gallery or site where you make your purchase. The diversity of the catalog and the gallery's reputation should be considered, but the most important consideration is your connection with the person you are dealing with. It is vital that you feel comfortable and at ease if you are to leave satisfied and reassured.

PROFESSIONAL POINTERS

Once you've completed all the preparations for your purchase, don't allow yourself to be constrained by preconceived notions. Let yourself be surprised by an artist, technique, or point of view that you might not have considered at the beginning of the process.

A Word of **Advice** from Fanny & Olivia

When you make your first purchase, begin by choosing the centerpiece of your collection. That will set your interior up for maximum visual effect. It will then be easier to fill out your decorative scheme with smaller-format pieces or arrangements that are more difficult to master when you start out.

Check out a new-generation gallery

DID YOU KNOW?

We gallerists set our prices with care, in close collaboration with the artists; at Wilo & Grove, they are fixed and non-negotiable. By holding to these prices, we are defending the work's value, which is not arbitrary, as well as the work of the gallerist, whose contribution is also significant.

A Word of **Advice** from Fanny & Olivia

We are absolutely convinced that the overall experience of purchasing a work of art should be pleasurable, and that pleasure should begin as soon as you walk through the gallery's door. If you still feel ill at ease with this idea, seek out galleries, such as ours, that do their utmost to provide warm, personal assistance, conveying the joy of living with artworks.

An innovative and simplified way to buy art

New concepts in galleries have recently emerged. They break traditional codes and better support buyers who wish to make their first purchase.

1. They offer a rich selection of works, guided by an artistic theme, that provides a varied but coherent range of choices in all formats and techniques—and for every budget. These new galleries allow clients to find a piece that's suited to their finances and scaled to their available wall space.

2. These galleries take a fresh approach to staging artworks. At Wilo & Grove, for example, the spaces are always arranged like an apartment interior, so visitors can envision the setting more easily, and to create a welcoming environment. We combine various artists and encourage our clients to experiment with bold juxtapositions, not confining themselves to a single dominant color or technique.

3. Some galleries post their prices. Transparency and availability of information are essential to provide reassurance to clients as they make their decision. The buyer will also know that prices are the same for everyone.

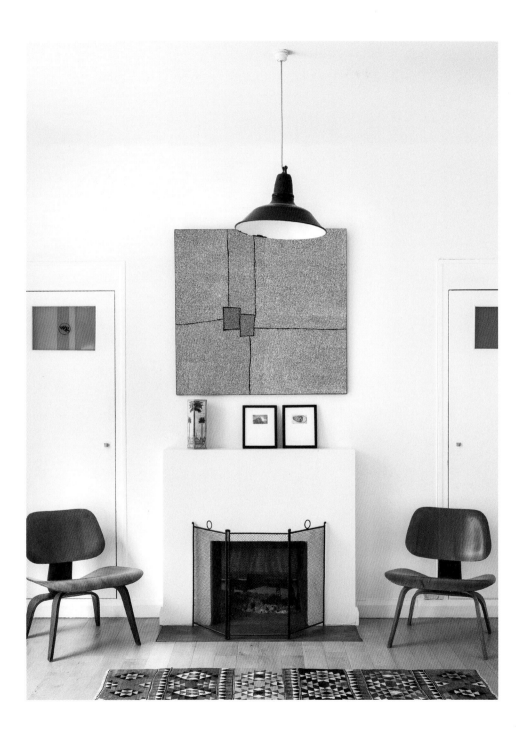

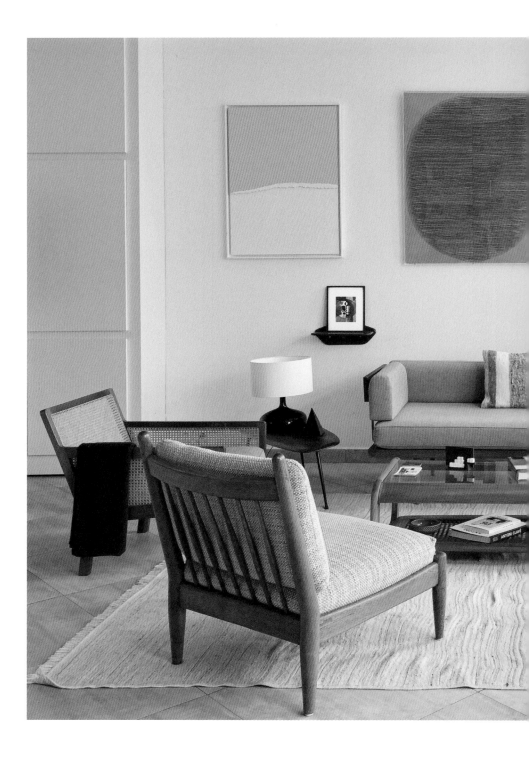

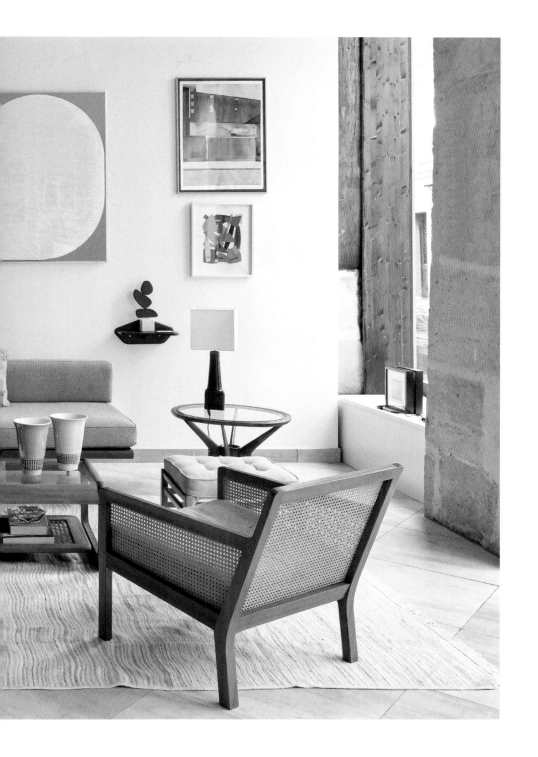

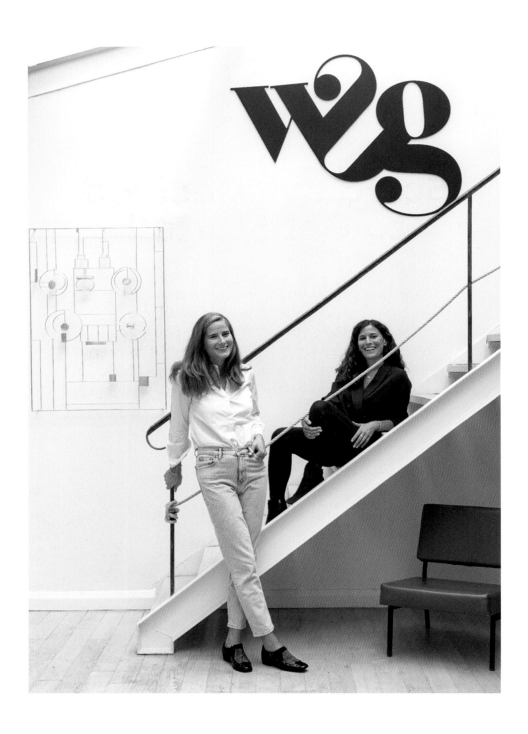

BE BOLD

So You've Decided to Get Started

Now that you've established your purchasing criteria, budget, and how you intend to buy your artwork, you're ready to encounter the masterpiece that, once welcomed into your home, will enhance your daily life. All you have to do now is choose. Here's how to go about it.

Purchasing a work of art for the very first time is a significant occasion. It's not unusual to be quickly taken by the urge to buy a second piece. Give in to temptation—that's how a collection begins!

Dare to choose without thinking (too much)

It's OK to fall in love

There may be objective criteria for determining the quality of an artwork, but it's impossible to objectively determine if it's beautiful or not. It's all a question of taste, so have confidence in yours! Love at first sight doesn't need to be explained; it just happens—so give in to it and buy.

1. You have to follow your heart to build a collection. Any other motivation (speculation or investment potential, for example) should be of secondary importance. Whatever the price, if you buy a work that you love, you won't go wrong. On the other hand, if you bet on an artist in the hopes that their work will gain in value without really loving the piece, you risk ending up with a bad investment *and* being burdened with a canvas that you don't even want to hang on your wall.

2. Don't attribute too much importance to your current decor when selecting a work. It will likely remain in your home far longer than furnishings and decorative objects, which will probably be replaced more often. In the course of your life, you might move and totally alter the look of your interior, but your artworks will be the most timeless element of that equation.

PROFESSIONAL POINTERS

When considering works by known artists, and above a certain price range, you should do your own research on their work, on prices, and on the galleries representing them, before you proceed.

A Word of **Advice** from Fanny & Olivia

Whether a novice or a seasoned collector, a buyer who visits a gallery is always looking for quality assurance and professionalism. Once these criteria are met, they can just focus on the feelings evoked by the artworks displayed. A good gallerist will talk with the client, working from photos of their interior space, in order to gain an understanding of their needs and intentions. Our ultimate goal is to bring together an individual and the work of art that was destined for them.

What if you're hesitant?

PROFESSIONAL POINTERS

Don't ignore your initial response to an artwork—often it is the most authentic—but also take the time to do a complete review of all your options and think them over carefully. Sometimes that "lightning bolt" feeling endures, but it may prove more fleeting.

A Word of **Advice** from Fanny & Olivia

Give yourself a moment before looking again at the work that you have just fallen in love with. That will give you a chance to ensure you still experience the same pleasure on second viewing. Depending on the situation, speak with the gallerist about any doubts you may have. A professional can usually offer to hold a piece that interests you for several days so that another buyer won't pluck it out from beneath your nose.

There's no rush

Falling in love with a work is ideal because there's no doubt: you know that this is the piece you want, and that's all that matters. But it's not always that simple.

1. That's just how it is—some people can make a purchase in a few minutes, while others need several days to finalize their choice. So don't beat yourself up if you don't leave the gallery with a picture tucked under your arm.

2. You may be buying the artwork for yourself, but often it will be hung in rooms used by other members of the family as well. It's important that everyone in the household agrees on the desirability of the piece, so make sure all involved have had their say before you make your decision.

3. If there are any doubts at all, it's best to study the piece you want to buy several times. These visits can also give you an opportunity to look at other pieces that you might not have noticed before. And sometimes, if you find you're still feeling hesitant, you have to admit to yourself that the work really isn't right for you and that it is best to forget it.

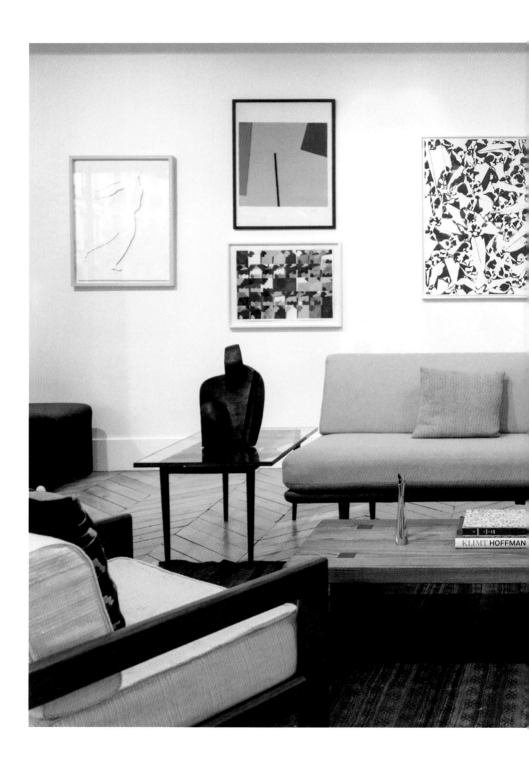

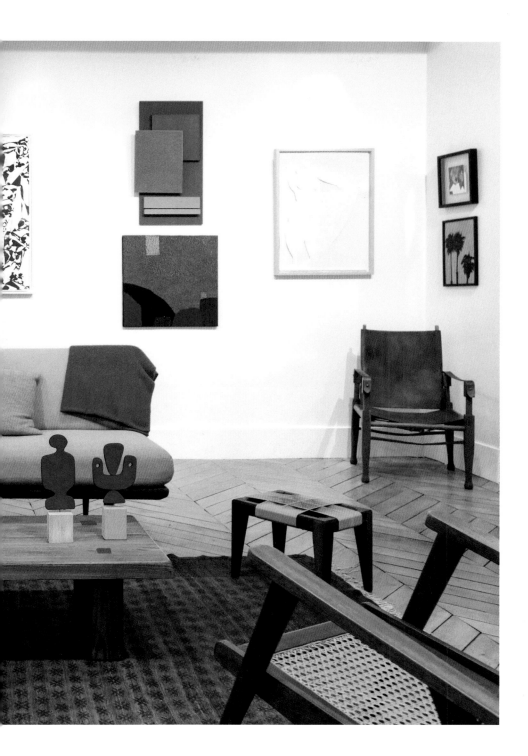

What to do if you regret a purchase

PROFESSIONAL POINTERS

Beware of purchases made at art fairs and salons: these are a special case, and the consumer has no legal right to cancel a transaction.

A Word of **Advice** from Fanny & Olivia

If you find yourself tiring of a work, it is possible to resell the work of known artists on the secondary market. Keep an eye on price movements and wait for an advantageous moment to sell at auction. You can also approach the gallery that sold you the piece, or another gallery that represents the artist, to inquire about offering it for sale.

Take action immediately!

You rush home, hastily unwrap the package, carefully pick up the just-purchased work, and realize it's a disaster. The colors clash horribly with your decor, or the canvas is much too large for the wall where it's supposed to hang.

Buying art is not without its perils. Of course, it's always preferable to take your time before making a decision, but don't despair if you know you've just made a mistake.

1. Check the legal position in the country of sale. Buyers are usually protected by basic consumer law rights in the case of online purchases—a "cooling off" period (usually fourteen days) after the receipt of goods, during which the transaction can be cancelled.

2. The work must be returned undamaged in its original packaging. Return costs are for the buyer's account. Once the vendor has received the returned piece and verified its condition, the buyer will be reimbursed.

3. For purchases made in person, there is no legal obligation, but the gallerist will very often give you the option of a refund or exchange within a reasonable timeframe.

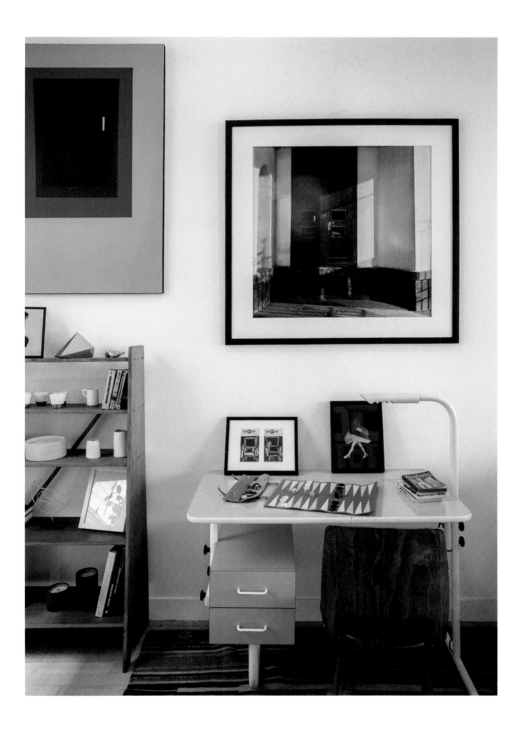

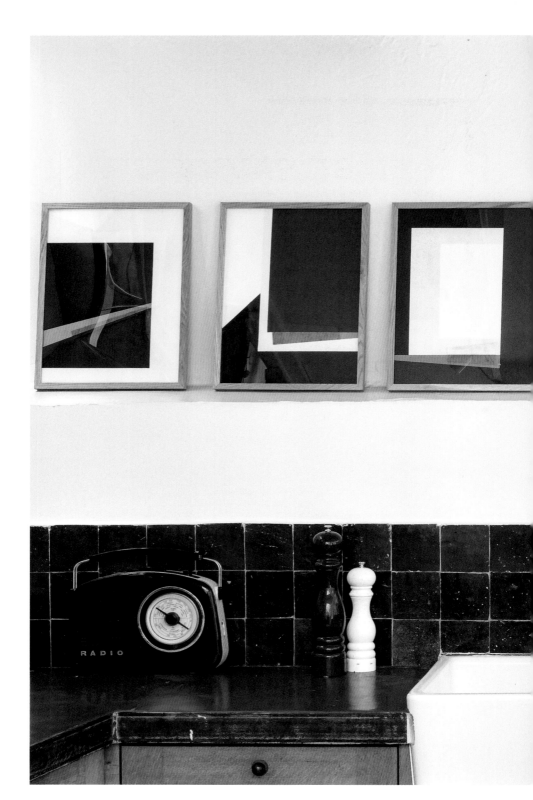

BE SAVVY

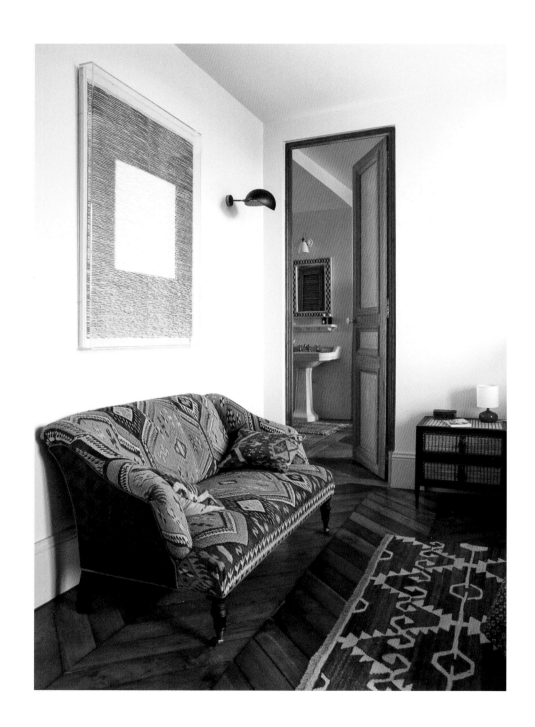

BE SAVVY

How to Become an Informed Collector

So, you've bought your second work of art.
Congratulations, you're officially a collector!
You'll find it hard to stop now, and your interiors
will soon be home to numerous additional treasures.
It's time to learn all the tricks of the trade in order
to be better organized. Here are our secrets for
managing your collection effectively.

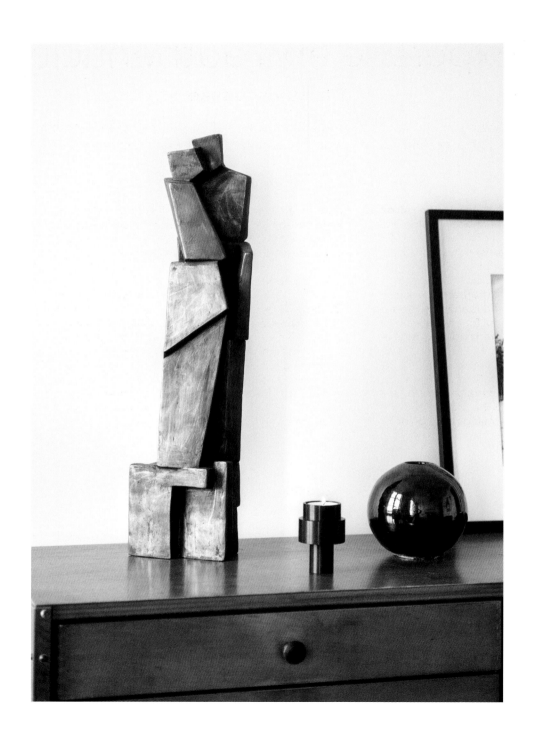

Expertise and authenticity

The steps to take

Whether you've purchased a work yourself or inherited it, it's essential to ascertain its authenticity. Here are several ways to go about it.

1. A catalogue raisonné (or critical catalog) lists all of an established artist's known work to date. It is regarded by the art market as an authoritative record, and is an indispensable tool for any sales intermediary. There is no need for a certificate of authenticity to confirm the status of a work that appears in the listing. These catalogs may be printed and issued in several volumes to include newly discovered works. Online catalogs are becoming increasingly common, as they facilitate updates.

2. Experts or committees are recognized authorities on a deceased artist, and are acknowledged by the market for their exhaustive expertise on the artist's oeuvre. They are often legal heirs of the artist, who are officially authorized to rule on questions of authenticity.

3. A certificate of authenticity may be delivered by artists or the gallery representing them in the case of a living artist, or by official experts if the artist is deceased. Don't misplace this document: it is unique and cannot be reissued.

PROFESSIONAL POINTERS

In the case of an auction, the seller and the auction house have a five-year obligation to the buyer, calculated from the sale date, covering the authenticity of the work purchased. For all other parties, this responsibility extends for twenty years from the transaction date.

A Word of **Advice** from Fanny & Olivia

If you think you are in possession of a work by a recognized artist, you can initiate your own process of authentication by a committee or an authorized expert. The Guide International des Experts et Spécialistes *(International Guide of Experts and Specialists) by Armand Israël is a useful source to help you find a reliable contact.*

Learn how to document your collection

The essential papers

If you wish to manage your collection properly, and later bequeath it to your heirs, it is crucial to retain all documents and information pertaining to its purchase, provenance, and value.

1. The purchase invoice. This document constitutes proof of the date the work was sold and its price: indispensable elements for making an insurance claim in the event of damage.

2. The provenance. The history of a work and its chain of ownership represent the "pedigree" of a piece. For older works, it is often difficult to trace these records, but this information will be requested in the event of a sale or for authentication.

3. The export license. Most countries have a system in place to protect their national cultural heritage through export control. Above a certain value and age of a work, an export license must be requested and obtained for the work to be authorized to leave its native territory—to be put up for sale, for example. If the work is considered to be of national importance, the administrative body of the country concerned may refuse permission for the piece to leave the territory.

PROFESSIONAL POINTERS

Keep all the labels glued to the back of a work, even if you change its frame. These are records of earlier exhibitions and sales.

A Word of **Advice** from Fanny & Olivia

If you wish to sell an artwork, a dossier containing all of these documents is invaluable. Provided with this information, a specialist at the auction house will be able to give you an estimate and recommendation for its sale.

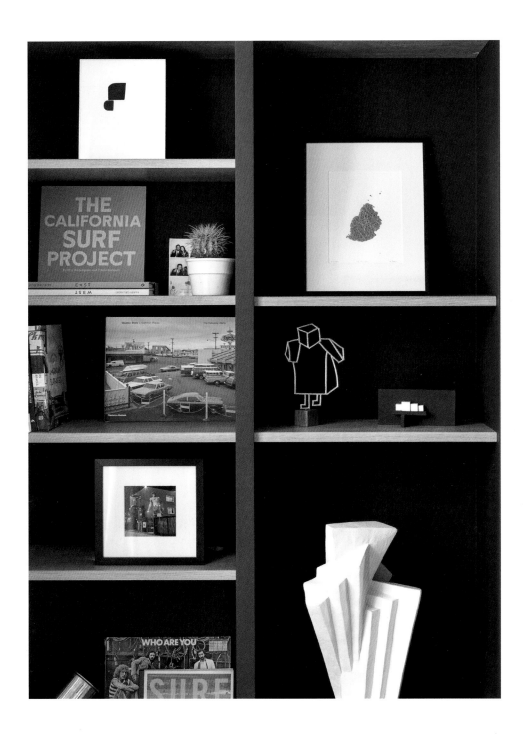

The taxation of artworks

Very particular conditions

A work of art is no ordinary product, and is subject to very specific fiscal regulations.

1. Taxation laws concerning artworks are complex and vary from country to country. Before embarking on a purchase or sale, you should ensure that you are fully informed of the particular fiscal regulations in your country of residence, as well as in the country where the transaction will take place.

2. In most countries, you are entitled to certain tax breaks, under specific conditions, if you donate artworks to charitable organizations or museums.

3. It is also possible in many countries to donate works of art to the State in lieu of payment of a portion of inheritance or estate tax. This process is known as "Acceptance in Lieu" in the UK. Countless artworks have entered national public collections in this way.

4. Freeports play an important role in the global art trade and allow collectors and dealers to avoid paying import taxes and duties on artworks they are storing or planning to sell. These highly secure storage facilities exist outside the territorial jurisdiction of any country, and the works are only subject to taxation and other customs duties once they have left the freeport.

DID YOU KNOW?

Upon artist Pablo Picasso's death, 203 paintings, 158 sculptures, 16 paper collages, 29 reliefs, 88 ceramic works, 3,000 drawings, and numerous illustrated works, manuscripts, and primitive artworks from his personal collection were donated by his family to the State in lieu of inheritance tax, forming the basis for the collection of the Musée National Picasso in Paris.

The Bigger Picture

In order to protect an artist's interests during their lifetime, and those of their family after their death (for the duration of copyright), a percentage of the sale price of an artwork is paid each time it is resold via an auction house or art dealer. This royalty, known as an "Artist's Resale Right," was first introduced in France in 1920, and was extended to the European Economic Area in 2001; however, it is not currently in practice in certain other countries such as the US, Japan, or China.

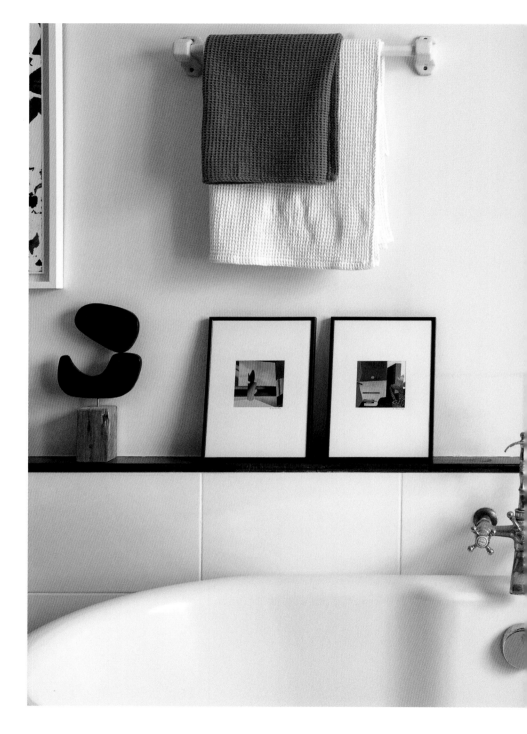

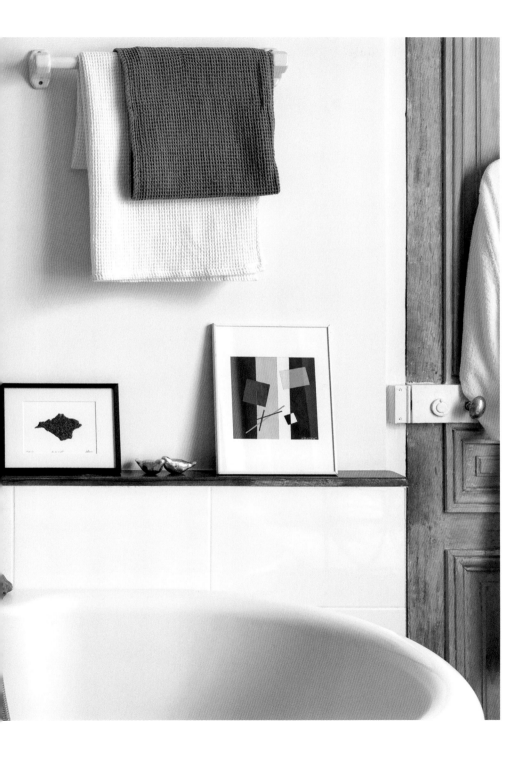

New collectors

Buyers' accounts

We can all be collectors! There are a thousand and one ways to own an artwork, and now that you have all the keys to get started, let yourself be inspired by the experiences of our clients, affectionately known as our Wilovers!

———————————

"I wanted to start an art collection two years ago, but I had no specific idea of what I wanted. I didn't have the time or the patience to wander from gallery to gallery in search of hidden gems—until I completely fell in love with a painting by René Roche on display at Wilo & Grove. It was a big investment, so, yes, I admit I had to think quite seriously before I made the leap. You could say that I gave myself a very nice Christmas present that year. And I have no regrets!"

Estelle

"We bought our first work of art because we wanted to make the most of the apartment we were sharing at the time. We pitched in together to buy an object that we'd both fallen for."

Nicolas and Thomas

"For us, providing ideas for displaying artworks— as at Wilo & Grove—is indispensable. That's what emboldens us to take the plunge and choose new works."
Yann and Laure

"As it happens, most of my artworks were gifts, either from my boyfriend or my friends. So I was surrounded by beautiful things even before I took the step of making my own first purchase. It was much easier for me to know what I wanted."
Adèle

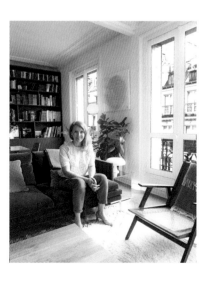

"The first thing I bought was a work on paper by Fernando Daza. I love the detail of the collage—you can admire the meticulous care of the artist's work as well as his spontaneous side. Wherever I go, I know this picture will follow me and have its own special place."
Fanny

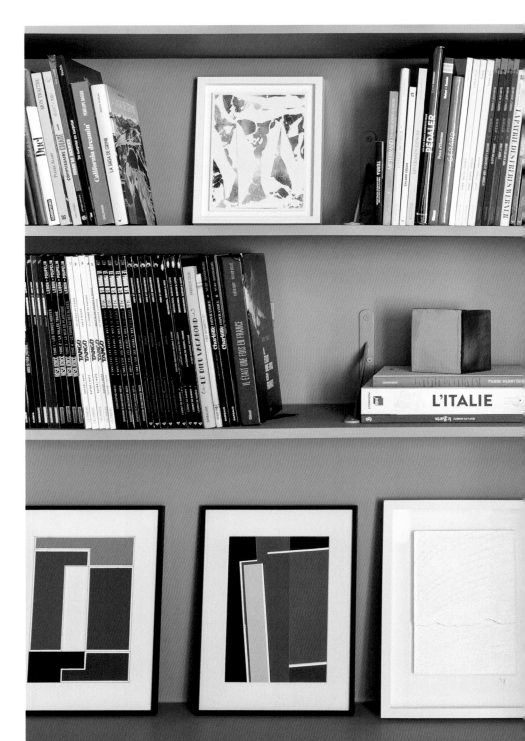

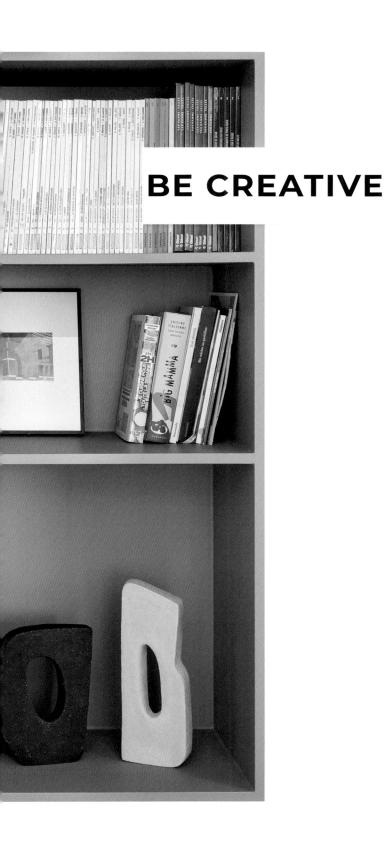

BE CREATIVE

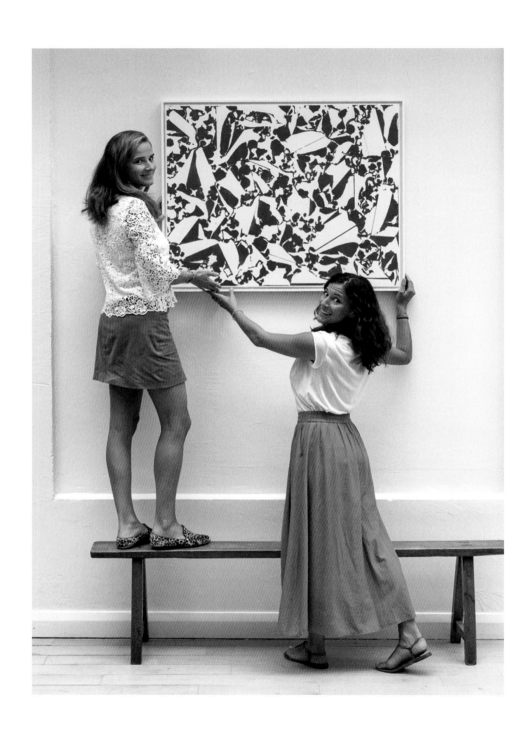

BE CREATIVE

How to Arrange Your Artworks

Perhaps you're still wondering about the ideal spot to display your recent acquisitions, or how to go about it. On the following pages, you'll find all our tips for showing your new artworks to best advantage.

Finding the perfect place

It's not always where you might expect

There are two possible approaches when buying a work of art: select a piece specifically to occupy a particular place, or purchase the work simply because you like it, then find the best place to display it. Whatever the case, don't leave anything to chance.

1. Some people swear by minimalist interiors, whereas others love to surround themselves with objects. It's all a question of taste and sensibility. More often than not, we decorate our homes fairly instinctively. Determining where to place an artwork, however, requires thought.

2. The choice of a work of art has a major impact on your interior. Its colors and energy will dominate the room. It is up to you to give it all the space it deserves, and not allow other strong pieces to offset its effect.

3. This is the perfect time to assess your relationship with the space and the room's overall decor. The arrival of a new work can trigger a number of changes, and that is why you shouldn't hesitate to move the furniture around, take down paintings, or reconfigure existing arrangements, if need be.

DID YOU KNOW?

Color was "a stick of dynamite" for André Derain, "a vigorous stroke of the gong" for Henri Matisse, and "the raw material indispensable to life, like water and fire" for Fernand Léger. Indeed, the spectrum of color has moved and enthralled us since time immemorial.

A Word of **Advice** from Fanny & Olivia

Artworks have a place in any room of the house. That's actually how we design our gallery, recreating various spaces in a typical apartment. Placing artworks in somewhat unexpected settings, such as in the kitchen, helps visitors to project and envisage doing the same in their own homes. In contrast to some stark, impersonal galleries, we also like to extend a homey welcome to our clients, over a relaxed cup of coffee.

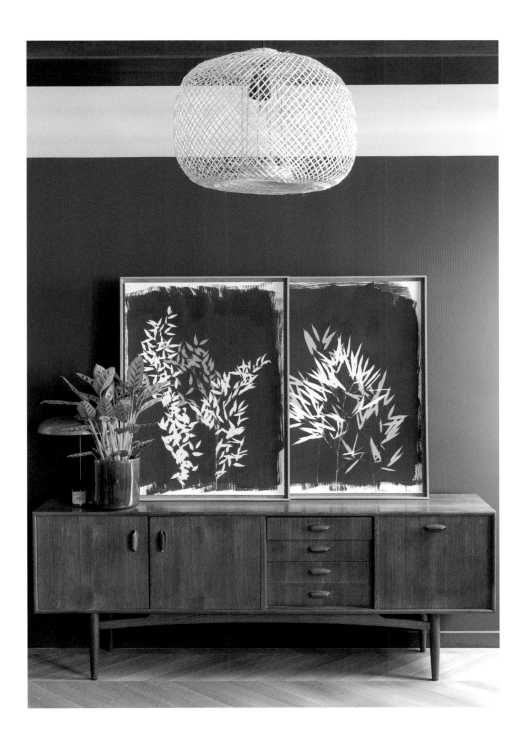

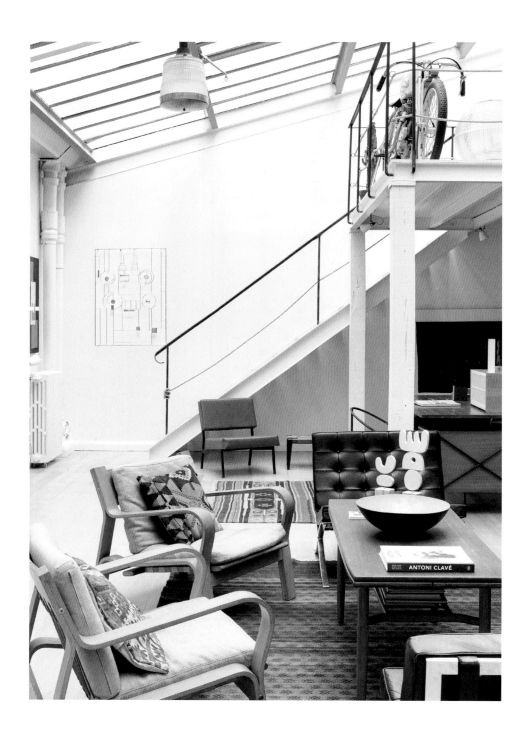

Art in every room of the house

So many possibilities to explore!

There's no one "perfect" room in which to display a work of art! On the other hand, you can't put an artwork just anywhere—its dimensions, the material it is made of, and its frame all need to be taken into consideration. Here are a few ideas for installing your acquisition in a suitable place.

1. The front hall is by definition the room where we're first introduced to your home, so it's essential to pay attention to the space and decorate it with care. A few well-chosen works of art will contribute both warmth and personality, creating a pleasing first impression for visitors. And these pieces will give you fresh pleasure every time you cross the threshold.

2. The setting for both festivities and more private moments, **the living room** is a space in which we generally spend a lot of time. Art can be deployed in little touches, using sculptures or minimalist works. However, as it is often the room with the most wall space, it offers a great opportunity to display large-scale artworks.

3. Increasingly open to the living room, **the kitchen** also deserves a decor worthy of the name. Kitchen walls are often covered with tall cabinets and tiling, leaving very little space to hang art. This is the perfect place to display smaller works that might seem a little lost in larger rooms.

PROFESSIONAL POINTERS

Ideally, the size of a painting hung above a sofa should not exceed two thirds of its length. Also, make sure that the work is placed high enough so it won't be damaged when you sit down.

A Word of **Advice** from Fanny & Olivia

An artwork is usually static, but it doesn't have to be. Install a mobile in the front hall: it will turn each time the door is opened or closed, offering an additional dimension—movement.

4. **The bathroom** is typically one of the smallest rooms in the house, as well as the most private. You can take advantage of this intimate space to hang works that are conducive to more private contemplation.

5. **The bedroom** is above all a place of rest, so it's best to select relatively serene works with fairly neutral graphics and colors that harmonize with the rest of the room's decor. The bedroom is also a place to display more intimate subjects.

6. As working remotely has become increasingly common, **the home office** is now an important room of the house, and it is essential to create a bubble of well-being for yourself, where you can focus and feel at ease. Positioned across from the desk, a well-chosen work of art or photographs of evocative themes can help to create a calmer, more productive working environment.

7. One or several works judiciously hung in your **child's room** will stimulate healthy childhood development—it's never too soon to introduce children to art! A work of art exists in its own right, but it can also be analyzed. Examine the work hanging in your child's room together: studying its composition, details, colors, and materials will lead to incredibly rich conversations that may inspire your child to later become a collector. It has been scientifically proven that a child's neural connections develop with every new experience during the first five years of life. The brain retains the most frequently repeated information, so if you want your children to love the arts, familiarize them with artworks from their earliest days.

PROFESSIONAL POINTERS

Don't neglect your hallways and corridors. Small-scale works hung at eye level will enliven these spaces, which can sometimes be dark and cramped.

A Word of **Advice** from Fanny & Olivia

Contrary to common belief, black and white is not necessarily a dreary option! Quite the reverse— it harmonizes with everything and retains a timeless quality, providing a touch of elegance and distinction to any style of interior.

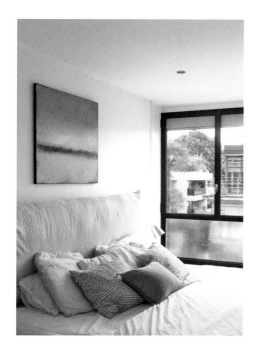

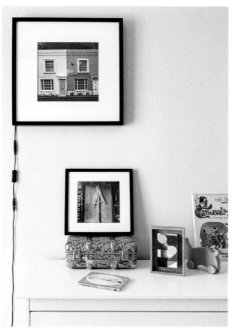

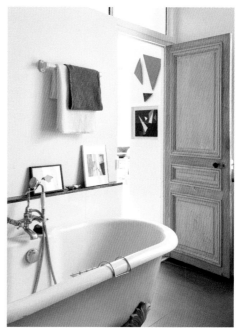

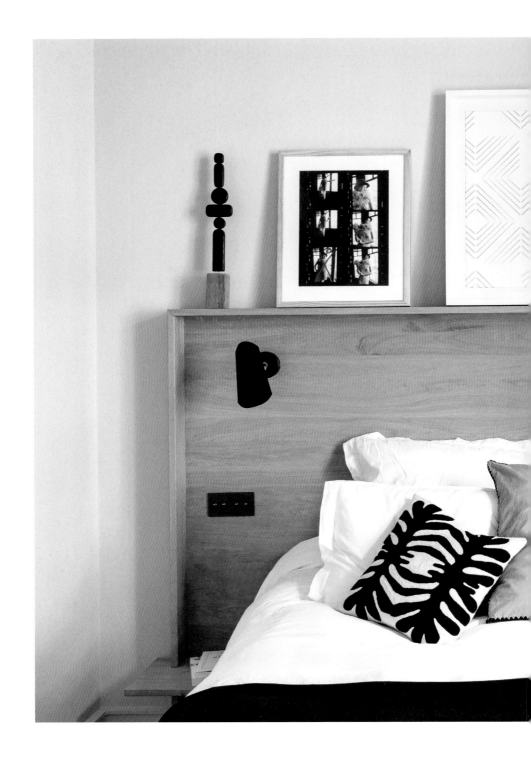

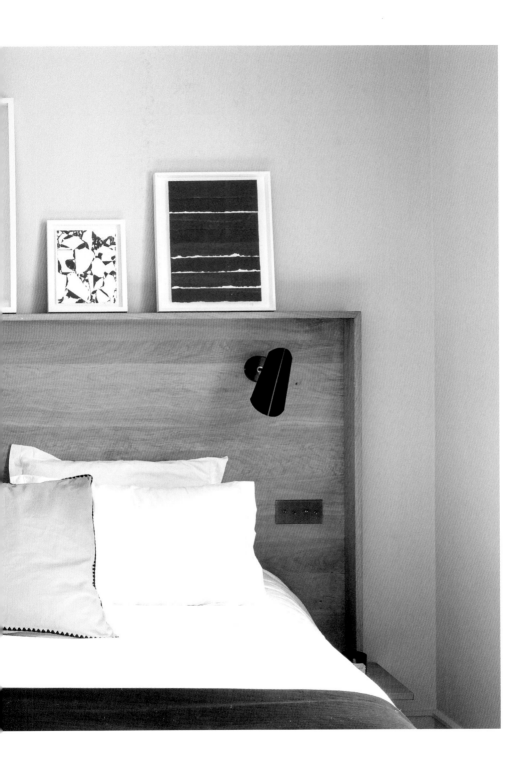

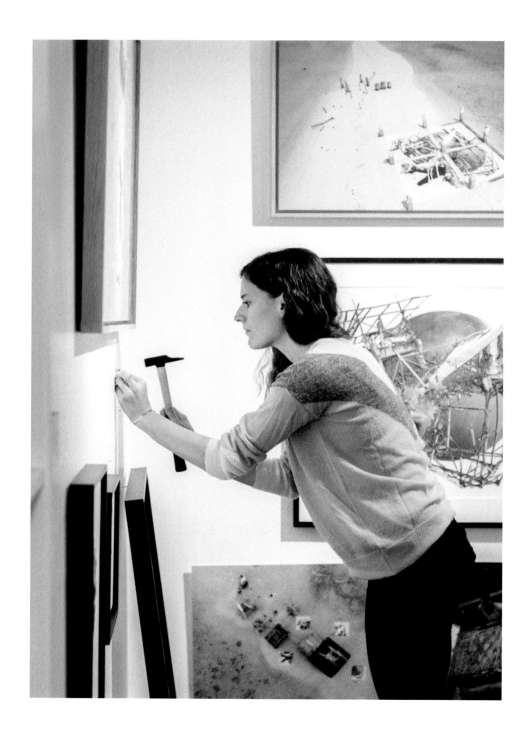

The right way to hang a framed artwork

With a hammer, a nail—and your brain

Hanging a single frame on a wall is a relatively simple task. But perfectly aligning two frames, one above the other or side by side, complicates matters considerably! Thanks to our tips, and a few little calculations, you'll be an expert picture hanger in no time.

1. Choose the place where you're going to hang your work, or works, with the utmost care before you embark on the daunting step of drilling a hole in the wall. In general, the placement of the artwork will have been decided on before the purchase is made—we often have a particular spot in mind when acquiring an artwork.

2. Once you choose the place and get the work home, it's time to determine if its scale corresponds to your expectations, and if it is suited to the wall space available. There is only one way of making sure you're right: ask a friend to hold up the work in the spot you intend to hang it, to see if this location still works.

3. If you've bought the work from a gallery, it may be possible to ask for a simulation (to scale) showing the work installed in various potential locations. That way, you'll get an impression that's closer to reality.

PROFESSIONAL POINTERS

Before you make a start, ensure you have all the equipment you need: a ruler or tape measure, pencil, hammer, and spirit level are indispensable. To hang heavy pieces, an electric drill, screws, and wall plugs may be required.

The Bigger Picture

When we design our installations, we envisage the placement of the works by various artists, the connections we can make between them, the groupings we wish to create, and the furniture to be displayed with them. As the works are purchased and leave us for their new homes, they're replaced by others. This ongoing construction project requires us to seek out a new sense of harmony each time. It is sometimes a brain teaser, but never less than interesting.

Hanging large or heavy frames

PROFESSIONAL POINTERS

For large, heavy pieces, position two hooks in the upper corners on the back of the painting. This will evenly distribute the weight, but you will have to make two holes in your wall, which must be positioned very precisely. If you're concerned that the picture may hang crooked, use a cable stretched between two pegs on the back of the work: this will allow you to correct the angle at any time.

A Word of **Advice** from Fanny & Olivia

To determine what your wall is made of, tap it with your index finger. If it sounds hollow, you have a simple partition wall. If the sound is dull, it's probably a load-bearing wall or made of concrete, which is a much tougher material. To be sure, drill a little hole in an inconspicuous spot, then examine the dust produced. If it is reddish, the wall is brick; if white, the wall is plaster; if fine and gray, the wall is concrete; if gray with slightly coarser grains, the wall is cellular concrete.

It's all a question of weight

A canvas alone isn't heavy—it's the framework that supports it and the glass covering that often weigh a lot. So, it's important to take certain safety precautions.

1. Identify what the wall is made of (see A Word of Advice from Fanny & Olivia). It's always best to ask a professional in a DIY store for advice on the material.

2. In addition to knowing the wall's material, you must ascertain the weight of the frame to ensure that the picture is appropriately hung. The maximum weight is always indicated on the box of hooks. For example, if the wall is plaster and your frame weighs less than 33 lb. (15 kg), select X picture hooks, which can be nailed into the wall using a hammer. For heavier frames, you'll need to drill and use expansion wall plugs. Special hooks for concrete are also available, which can be used within the same weight limit to avoid drilling.

3. Galleries often use picture rails, and these can be easily installed in your home. A rail is attached to the wall, just below the ceiling, from which a flexible or rigid rod is hung vertically. A sliding hook is then attached to the rod, to hang the painting at the desired height. This system allows heavy frames to be hung without making holes in the wall, and you can adjust the positioning of the picture at will.

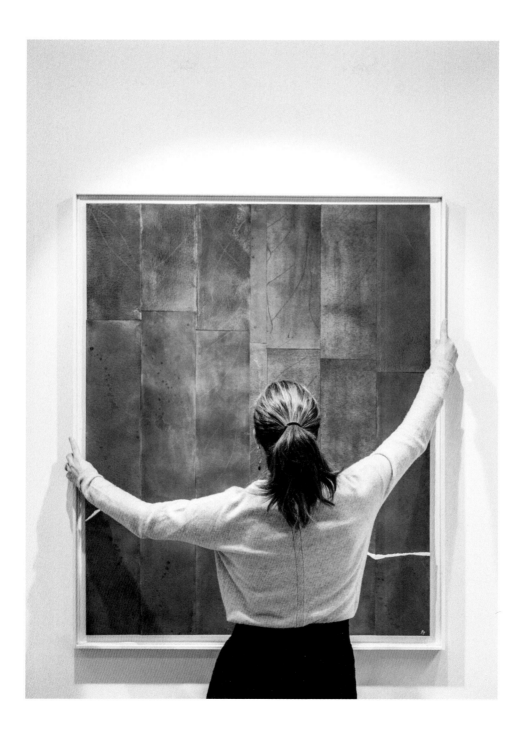

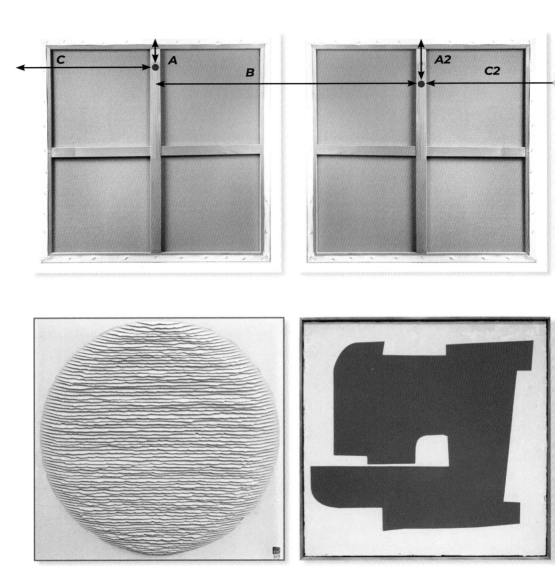

Remember that a work (or group of works) should not occupy more than two thirds of the wall, to avoid overloading the room.

Aligning two works by centering them on a wall

1. When you've decided on the placement of the works on the wall, lay them out on the floor in front of you, with their backs facing upward. Arrange them with exactly the same space between them as there will be once they are hung on the wall.

2. Measure the space between the upper edge of the picture on the left and its hanging system. Make a note of this measurement, which we will call **A**. Do the same with the other picture: we'll call this measurement **A2**.

3. Measure the distance between the two hanging systems. Make a note of this measurement, which we'll call **B**.

4. Measure the distance between the hanging system of the picture on the left and the left-hand edge of the wall (**C**). It should be equal to the distance separating the hanging system of the work on the right from the right-hand edge of the wall (**C2**).

5. Use a pencil to mark these last two measurements on the wall with little crosses.

6. Aligning yourself vertically with the left-hand cross, mark (using a ruler or tape measure) the distance you want between the ceiling and the upper edge of the picture. Add **A** to this measurement and draw a new little cross in pencil. Place your first wall hook here.

7. Attach a piece of string the length of **B** to this hook, pull it toward the right, using a spirit level to ensure it is accurately aligned, and draw a cross.

8. Aligning yourself vertically with this cross, mark (using a ruler or tape measure) the desired distance between the ceiling and the upper edge of the work. Add **A2** to this measurement and place your second wall hook here.

9. Remove the string and hang your pictures; they should be perfectly aligned. Check with a spirit level.

Displaying small or medium formats

PROFESSIONAL POINTERS

Works that weigh very little can be mounted directly on the wall using invisible double-face adhesive systems, such as Velcro attachments that are placed on the back of the frame and on the wall. These can be removed without damaging the painted surface.

A Word of **Advice** from Fanny & Olivia

If your collection is large, there may not be enough wall space to hang all of the works. No problem—just prop them up on the floor, on a sideboard or dresser, or on narrow shelves of various sizes with little ledges.

The best options

As with large pictures, the weight of the frame and the composition of the wall are vital considerations when hanging your works.

1. Once you've determined the composition of the wall on which you plan to hang the pictures, it's time to consider how to arrange them. Remember that small- or medium-format works will seem lost if hung on a vast expanse of wall. It's better to choose a space between two windows or doors, or a small entryway. Make sure you hang the works at eye level (about 5¼ ft. [1.60 m] above the floor).

2. There's a very simple trick that allows you to visualize the spot in which you're intending to hang a work before you make a hole in the wall. Just cut out pieces of paper with exactly the same dimensions as the pictures, then attach them to the wall with masking tape. Once you've ascertained the best placement on the wall, mark the position of the corners using a pencil. This technique is also very useful for testing out and creating compositions.

3. If you're hanging several works in the same room, but not necessarily side by side, it's best to align them by their midpoints, not by their upper or lower edges, for the most harmonious effect.

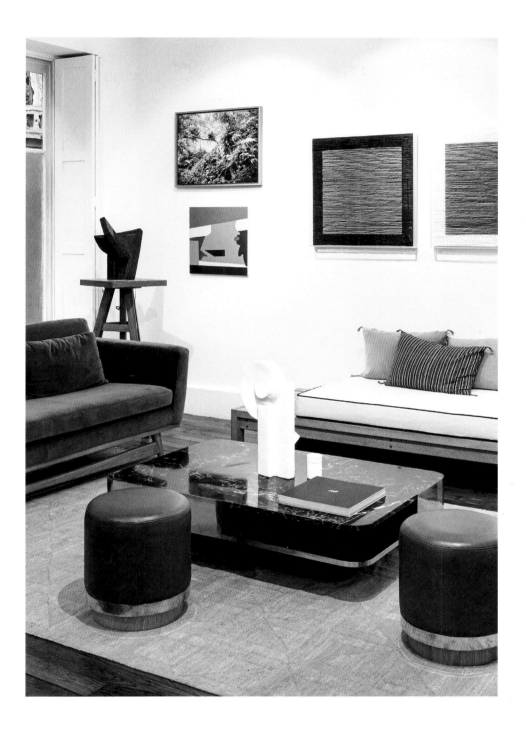

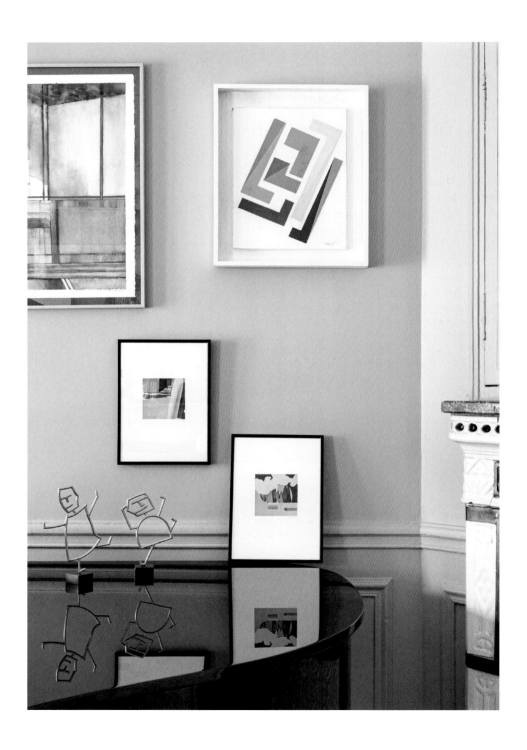

Mastering the art of composition

It's much simpler than you might imagine

A wall display comprising a multitude of works is ultra-trendy, but a certain degree of expertise is needed to compose one. You can give free rein to your creativity and arrange the works following your instincts, or opt for a structure that you've thought long and hard about. It's up to you.

1. You'll need to select the pieces to be hung together very carefully and precisely. Color harmonies (similar tones or colorful variations), related themes, similar techniques, frames of similar or contrasting styles—you have to determine your ideal composition.

2. One of the pieces in the composition may dominate the others (by virtue of its colors, format, or subject), and you'll need to take this into account so that it doesn't overwhelm its neighbors. One possibility is to place it on one side of the arrangement, counterbalancing the other side with an equally strong work.

3. If you want to enliven and personalize a composition of any kind, consider including other items, such as mirrors, personal photographs, or a variety of decorative objects. Of course, you should always leave an appropriate distance between the works.

PROFESSIONAL POINTERS

The space between pictures must be adjusted according to the size of the works. It might be ¾ in. (2 cm) between small pictures; in contrast, you can leave the equivalent of a hand's width between two large-scale canvases.

A Word of **Advice** from Fanny & Olivia

We often have to lay out all the pieces we want to arrange together on the floor, before mounting them on the wall. This process allows us to move things around easily while we determine the most attractive composition. We can then take a photograph and recreate the arrangement on the wall. It is entirely possible to hang a grouping of small works in a free composition, without any particular alignment, which will easily accommodate new acquisitions (see p. 110). Or, on the contrary, you can opt for a more systematically arranged composition, aligning all the frames by their outer edges (see p. 111).

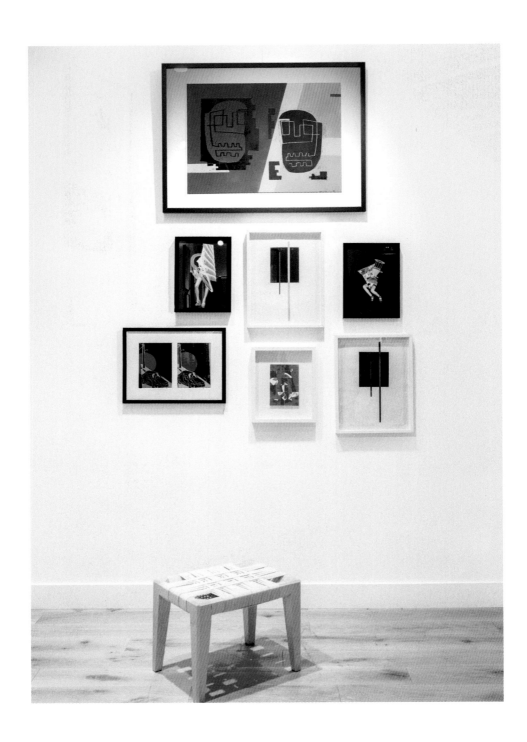

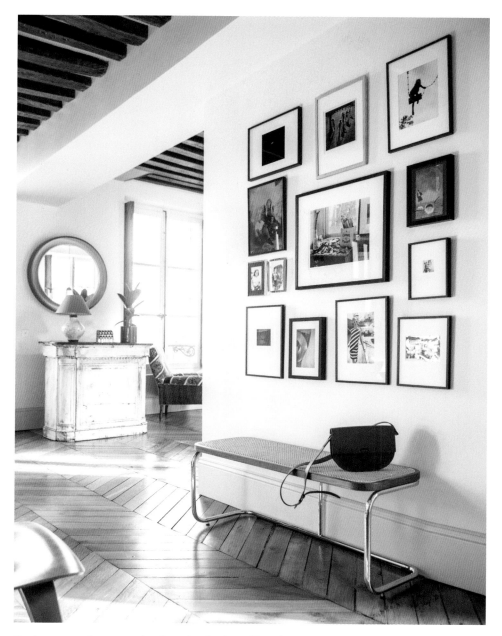

Facing page: An example of works displayed in a free composition, known as "in the clouds," at Wilo & Grove.

Above: An example of a composition of works aligned by their outer edges.

Transform the books on your bookshelves into attractive display bases for your small-format pictures and objects by piling several together with their colorful spines showing. Alternate different heights to create a livelier visual rhythm.

The art of combining objects

Artful mixes

Those collectors who are just starting out may find themselves surrounded with works that need to be artfully arranged: ceramics, sculptures, small framed pieces, etc. It just takes a few ideas and tricks to create happy marriages that can last a lifetime or facilitate the formation of attractive blended families.

1. Each collector is free to appropriate their space and arrange it as they see fit, to reflect the multiple facets of their personality. Mixing and matching is therefore often called for, and can lend rhythm and originality to the decor. Beware though: the collection must be ordered and organized if it is to be successful.

2. In a bookcase, you can combine works (including small paintings, sculptures, and ceramics) and intersperse them with everyday objects, such as vases, flowers, and books with attractive covers.

3. Knowing how to combine objets d'art is an art in itself. Feel free to rework existing compositions on a regular basis, trying out new groupings or changing frames. You can also experiment with monochrome or colorful arrangements. And don't hesitate to mix subject matter: very figurative photographs harmonize beautifully with abstract art.

PROFESSIONAL POINTERS

Little alcoves and bookshelves are compact spaces that are often just the right size for displaying small artworks. These accessible locations allow the viewer to get close to the piece and admire its smallest detail.

A Word of **Advice** from **Fanny & Olivia**

Happiness lies in contrast. Juxtapose styles and periods. There's no risk involved: unlike paintings, objects are not fixed in one place and can be moved around on a whim. By trying out various arrangements, you'll educate your eye and hone your artistic instincts.

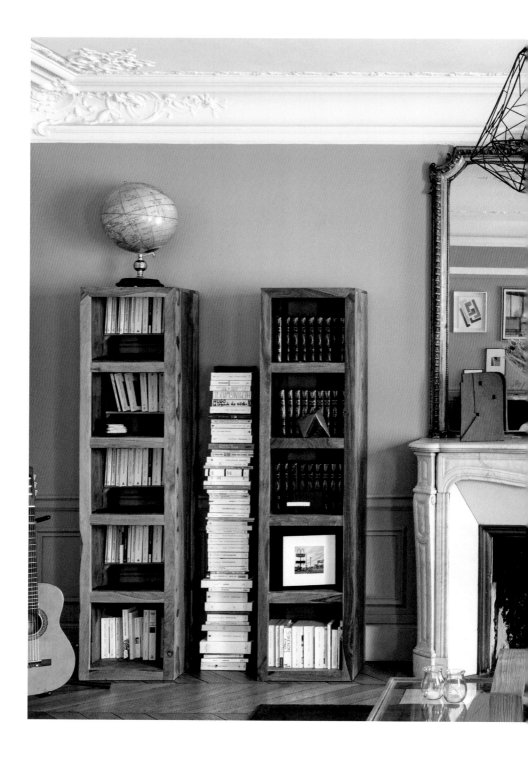

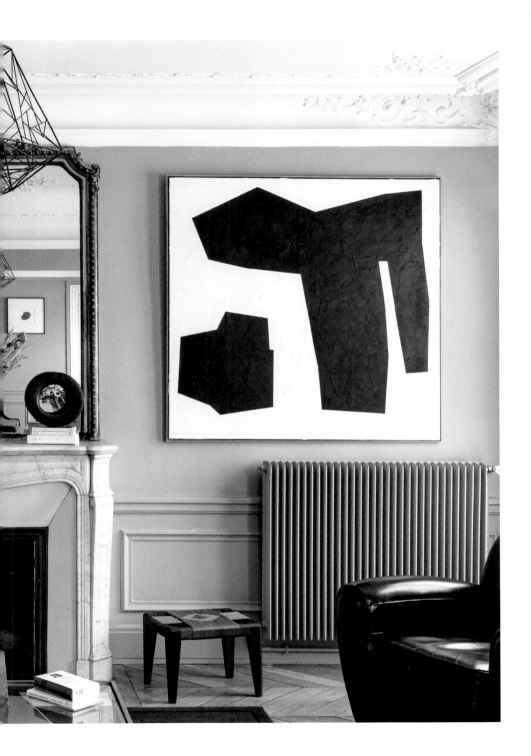

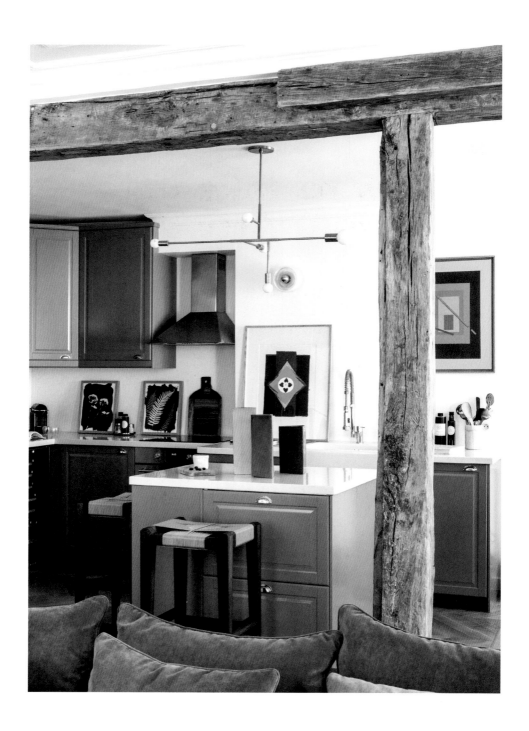

BE CREATIVE

How to Take Care of Your Artworks

Works of art are unique, often fragile, and,
most importantly, irreplaceable. It's essential to display
them to best advantage and maintain them in optimal
conditions. Follow our invaluable advice to ensure
your precious acquisitions are properly conserved.

The secrets of framing

A multitude of options

It is essential to frame your artworks, both to show them to good advantage and to protect them. Care should be taken when choosing suitable frames. Here's how to go about it.

1. Frames without glass. Often reserved for canvases, these frames give works a powerful presence. They range from traditional formats to floater frames. Traditional frames are placed directly on the canvases and cover the edges by about ½ in. (1 cm). With a floater frame, the painting is inserted into a kind of custom-made box, leaving the edges visible.

2. Frames under glass. This type of frame is required to protect photographs or fragile works, and is the perfect choice if the glass has been treated with an anti-UV and antireflective coating. They can be used with a mat board (also known as a picture mount; see Glossary, p. 129), but the irregular edges of art paper lend a charm of their own.

3. Colors and materials. Unfinished oak frames create a warm and welcoming effect, whereas black frames have a more chic and contemporary look. If it's an original, sophisticated, or top-of-the-line job that you're after, get advice from a professional framer. Mat boards or frame liners (see Glossary, p. 128) can be paired with your frames.

DID YOU KNOW?

Don't be surprised if some contemporary paintings are presented unframed. It's a common practice favored by many artists today.

A Word of Advice from Fanny & Olivia

It's not always easy to choose the ideal frame. That is why many galleries, such as Wilo & Grove, sell works already framed. That way, you don't have to ask yourself too many questions, and, more importantly, the work can be hung as soon as you get home, without having to wait for it to be framed, which can often take several weeks.

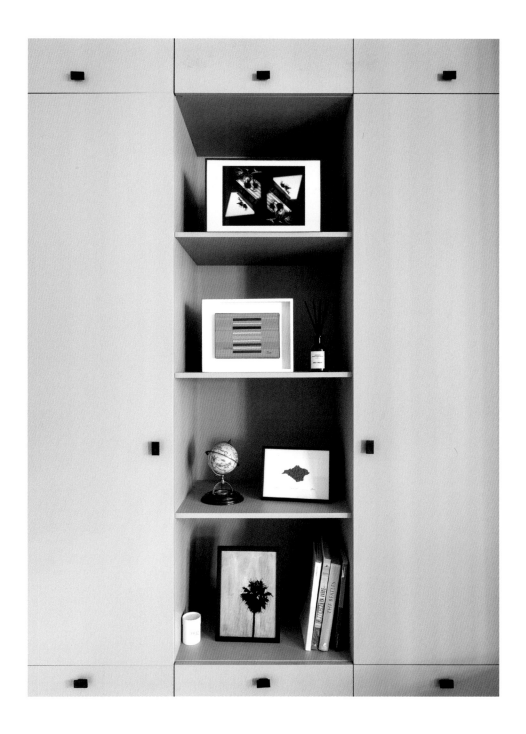

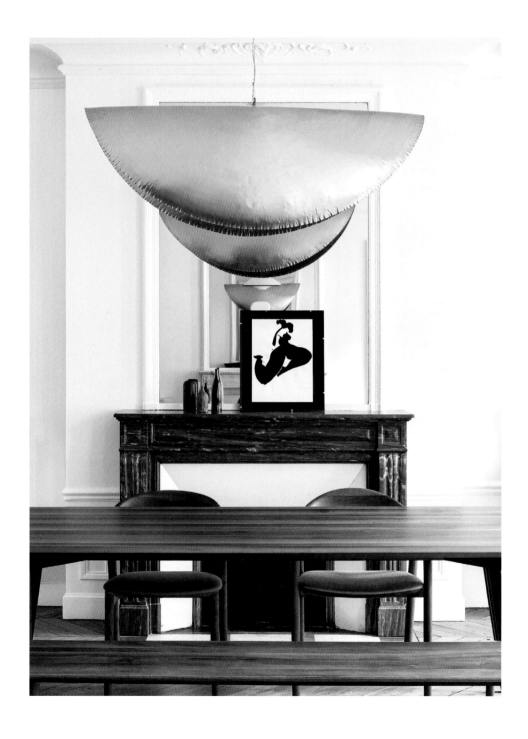

Don't forget the lighting

A crucial question

Nothing is more frustrating than not being able to see a work of art properly, simply because it is badly lit. The issue of lighting is a major challenge for professionals as well as collectors. Here are a few guidelines.

1. Spotlights are the best way of illuminating works of art. Simple to install, they can provide one or more sources of light that can be redirected and adjusted depending on the requirements. Spots now use LED bulbs; they present no danger to the work they are illuminating and make the most of its qualities.

2. If you can't install spot track lighting, consider wall or ceiling fixtures with adjustable clamps that can direct light toward objects on the wall.

3. Old-fashioned light bulbs release UV rays and considerable heat. Avoid using them to illuminate artworks. They have the same effect as direct sunlight and are highly destructive to all types of pigment. Study the information labels on lamps and bulbs and go for LEDs wherever possible. Consider standing spotlights, which are easy to place and move around as needed.

PROFESSIONAL POINTERS

Take advantage of natural light without annoying reflections by hanging paintings in unglazed frames directly across from windows. If that is not possible, you can use frames with antireflective glass.

A Word of **Advice** from **Fanny & Olivia**

Framing projectors are directional spotlights with a beam that can be adjusted to correspond exactly to the shape and size of a painting, outlining its contours and framing it with light. They are absolutely perfect, but traditional spots are fine for most pieces. Standing spots are movable and allow you to adjust the lighting with ease. Finally, try to use several sources of light in the room. They'll create a warmer atmosphere and also contribute to the indirect lighting of the artworks.

Preserving your artworks

Mistakes to avoid

Before you hang a painting or photograph, you need to consider the environment in which the work will be displayed, day after day. Exposure to UV rays, potential splashes, or rooms with high levels of humidity—these are a few of the many factors that could seriously damage your collection. Here's what you need to know.

1. Paintings are far sturdier than works on paper, which are much more fragile, especially when subjected to humidity.

2. If works on paper (drawings, collages, photographs, lithographs, and so on) are placed in a location exposed to strong sunlight, it is essential to protect them with antireflective and anti-UV glass.

3. As a general rule, works on paper and photographs should not be exposed to direct sunlight, which can be very destructive. The work may deteriorate or discolor, and stains can appear on the paper.

4. Works on paper don't do well in bathrooms or kitchens either: the constantly humid atmosphere will damage them, causing the support to buckle, for example. Also, avoid placing paper works close to a radiator, as they can dry out and become brittle.

5. Whatever the nature of your artworks, they must never be stored in damp locations such as basements. Even if well wrapped, they are at risk of deterioration over time.

6. For works framed under glass, remember to ask the framer to leave a space between the glass and the paper— this will provide better protection. You can also use a mat board, which will serve the same purpose.

7. It is best to display works in an environment that has stable temperature and humidity levels: it is the fluctuations that produce the most damage.

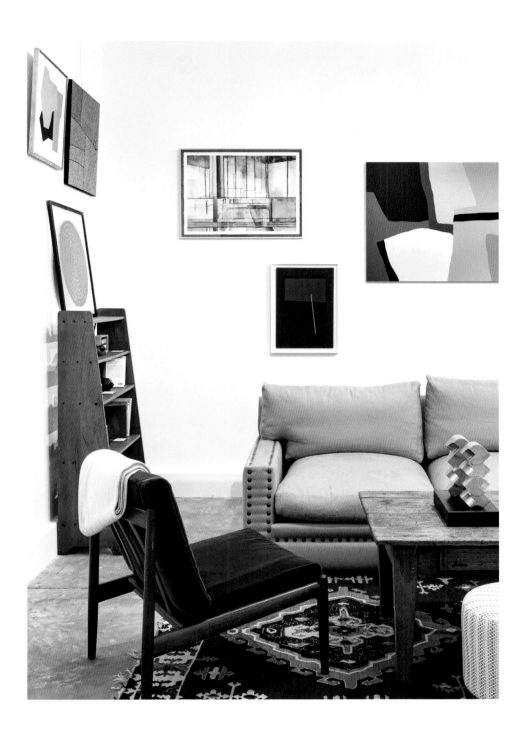

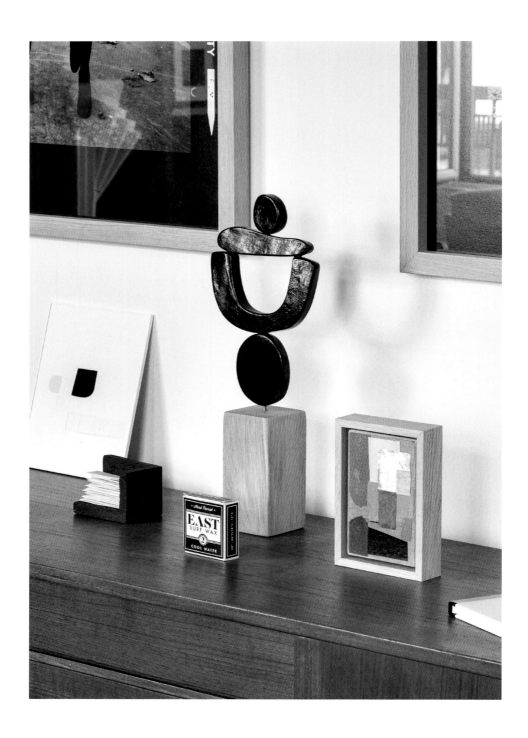

Restoring a work of art

There's a solution for every problem

If subjected to careless handling, or just wear and tear over time, an artwork may deteriorate or even become damaged. Some problems can be resolved with quick and simple solutions. In more serious cases, it's preferable to get professional assistance.

1. Works on paper. A mat board of inferior quality may, over time, leave a dark mark on the paper due to the acidity in its formulation. In this case, all you need to do is replace it with a new mat with a neutral PH (framers usually have these in stock). They are very affordable and will help preserve your work.

If the paper develops stains or foxing (see Glossary, p. 128), or it tears, get an estimate from a specialized restorer. They can often work miracles at a reasonable cost.

2. Paintings. Over time, a painted work may begin to show signs of deterioration, such as cracks in its finish, flaking paint, yellowing varnish, or it might simply accumulate a layer of dust and dirt that tarnishes its colors. Paintings may also be accidently harmed through rips or tears. A restorer can repair or at least mitigate such damage.

PROFESSIONAL POINTERS

If you have a black wooden frame that gets scratched, just apply a little black wax to the scratch using a rag, or else a small touch of black marker (after filling in the crack with wood putty if necessary). That should cover it.

A Word of **Advice** from Fanny & Olivia

If you're having a painting restored to attenuate the signs of aging, make sure you specify that you require a light cleaning. You don't want your painting to be stripped, which can take away its character and destroy the handsome patina that adds so much to its appeal.

BE CURIOUS

Glossary

The essential terminology

Here are a few useful terms
that every art collector should know.

Attributed to: This term generally refers to an unsigned artwork that, to all appearances, was executed by a certain artist but has not yet been appraised, or to a work whose authorship cannot be fully confirmed by experts.

Buyer's premium: A supplemental fee that is added to the hammer price (see right) of a work sold at auction. Depending on the auction house, this may range from 15 to 30 percent.

Condition report: A document prepared by a specialist or a restorer prior to a sale. It documents the exact condition of the work. This information, particularly anything pertaining to evidence of heavy-handed restoration, should be studied carefully before making any significant purchase.

Edition: An edition is a set of identical artworks created using an original master. The term can refer to a range of media, including a series of prints made from the same printing plate or printing surface, photographic prints, or sculptures. Considered to be works of art, they are produced in limited numbers and are usually signed, numbered, and dated by the artist. In the case of sculpture, casts are made from a mold of the original work, and their production, which is tightly controlled by the artist or their legal successors, is limited to eight numbered copies. In addition to these, up to four special artist's proofs, which serve as initial "tests," may be included.

Foxing: Small yellowish-brown spots on paper caused by humidity, age-related deterioration, or contact with acidic surfaces (poor-quality framing materials, for example).

Frame liner: Also known as a linen liner, this is a fabric-covered wooden molding, placed inside the outer molding of a frame. It serves both a decorative and protective purpose, as it separates the artwork from the frame. Liners should not be confused with mat boards (see facing page): liners are traditionally used for canvas paintings or prints in unglazed frames, whereas mats are usually reserved for paper works in frames with glass covers.

Hammer price: The definitive price for which a lot is sold at public auction. The purchaser will also pay

an additional buyer's premium (see facing page).

Lining: Originating in the eighteenth century by restorers at the Musée du Louvre, this is a method of reinforcing an original canvas that has become damaged over time with cracking, tears, stretching, or mishandling. The old canvas is glued to a new one. It should be noted that lining can do serious harm to the painting's materials and should be used only in cases of very severe damage.

Mat board: Also known as a passe-partout, or picture mount in British English, a mat board is a cardboard insert with a large opening in the center that is placed between the artwork and the glazed frame. Mats are used for works on paper to keep them from coming into direct contact with the glass. They also have an aesthetic function, providing additional decoration and an attractive finish, or covering up a work's uneven or damaged edges. Mats are often confused with frame liners (see facing page), which are usually used for framed works on canvas without glass frame covers.

Picture rail: This picture-hanging system is frequently used in galleries to hang framed works. A rail is mounted flush with the ceiling, and a flexible or rigid rod is suspended vertically from it. A sliding hook is slipped over the rod to hang the picture at the desired height. Picture rails allow you to hang heavy paintings without having to drill a hole in the wall, and you can adjust the artwork's position as often as you wish.

Stretcher: An assemblage of wood bars to which a canvas is stretched and attached using nails or staples.

Sun damage: Discoloration or deterioration of the paper support of a work or fading of colors (in the case of water-based techniques) due to exposure to UV rays.

White glove auction: An auction in which all lots are sold. In the event of such a rare achievement, the successful auctioneer is traditionally awarded a fine pair of white gloves.

Workshop of (followed by the artist's name): The painting was executed under the artist's supervision in his studio, presumably by one of his students.

Instagram inspiration

Captivating accounts to follow

These are some of our recommendations
for inspiring Instagram accounts
(in addition to @wiloandgrove, of course!)

To find ideas to incorporate art into your interior design:

@goodmoods: This online magazine with its finger on the pulse predicts and showcases future trends in interior design and home decoration, in the form of colorful and graphic mood boards.

@kbergart: The account of this decorator for the Counter-Space boutiques in Los Angeles combines art and vintage design with originality and simplicity.

@m.a.r.c.c.o.s.t.a: This account features reposts of the most inspiring interiors from around the world, with a particular focus on incorporating art into our daily lives.

To have fun with art:

@tussenkunstenquarantaine: Launched in 2020 during lockdown, this account publishes photos of people recreating famous paintings and other artworks at home, using everyday household items.

@matchwithart: By modeling outfits that perfectly match the artworks she is standing in front of, the creator of this account captures the viewer's attention in an imaginative way, while presenting the work of modern and contemporary artists.

@punk_history: Characters from the greatest paintings in art history are catapulted into the modern world thanks to humorous captions featuring imaginary dialogues.

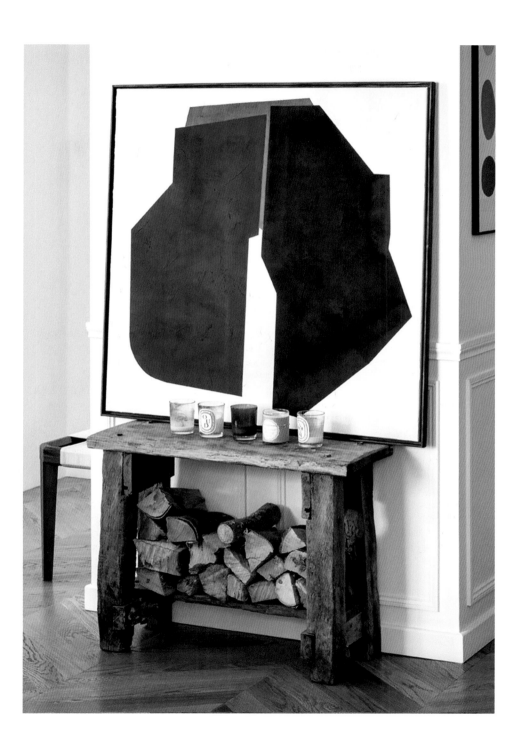

List of works

Discover our artists

The Wilo & Grove adventure would be nothing without the artists whose work we've exhibited since we founded the gallery. Their creativity has provided us with a rich, diverse selection with which to illustrate this book. Here's a list of the artworks featured on these pages.

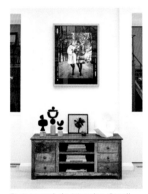

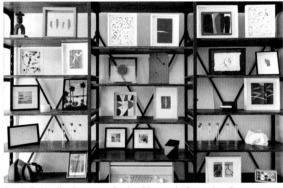

P. 4: Hervé de Mestier, *Stroll*, *Vogue*; Amélie Dauteur, *Fomu*, *Torofi*, and *Tomodashi*; Hubert Jouzeau, *Small Palm Tree*; Danielle Lescot, *Small Faceted Ball*; Patricia Zieseniss, *Adolescence*. Photo © Hervé Goluza.

Pp. 6–7: Amélie Dauteur, *Otoko*; Plume de Panache, *Cotton House* and *Wilo III*; Laurent Karagueuzian, *Stripped Papers Nos. 63, 119*, and *242*; Bernard Gortais, *The Life of Folds Nos. 7 and 11* and *Continuum 152*; Mise en Lumière, *MacDonalds, New Orleans*; Hubert Jouzeau, *California Top*; Jean-Charles Yaïch, *Woman II* and *Kirigami*; Anne Brun, *Gilded Flowers in Pure Gold*; Patricia Zieseniss, *The Bear* and *Hedgehog*; Éliane Pouhaër, *Light*; Agnès Nivot, *Staircases Wall 2* and *Cube Collection 7*; Michaël Schouflikir, *House of Cards* and *People*; Margaux Derhy, *Gate of the Anti-Atlas 14*; Thibault de Puyfontaine, *Parasol* and *Yellow Car*; Danielle Lescot, *Medium Reef*; Joël Froment, *Untitled*; Baptiste Penin, *Dominica*; Claire Borde, *Counterpoint No. 9*; Emma Iks, *Two Geese*. Photo © Hervé Goluza.

P. 24: Jan van Eyck, *The Arnolfini Portrait* © The National Gallery, London, Dist. RMN-Grand Palais / National Gallery Photographic Department.

P. 32: Business sign on the facade of Christie's Geneva branch. Photo © Godong / Getty Images.

P. 35: Camille de Foresta at the auction block. Photo © Christie's.

List of works

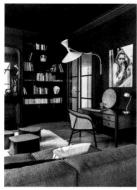

P. 11: Patricia Zieseniss, *Couple II* and *The Journey*; Plume de Panache, *Como*. Photo © Sophie Lloyd for the interior architect Caroline Andréoni.

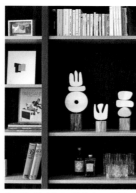

Pp. 12–13: Michaël Schouflikir, *Japan*; Claire Borde, *Counterpoint No. 4*; Amélie Dauteur, *Atama*, *Tsuno*, and *Nodo*. Photo © Hervé Goluza.

P. 14: Marie Amédro, *Ensemble No. 4* (detail). Photo © Hervé Goluza.

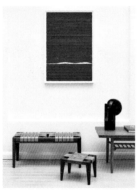

P. 17: Bernard Gortais, *Continuum 170*; Biombo, *Double Bench* and *Stool*; Patricia Zieseniss, *Friend*. Photo © Hervé Goluza.

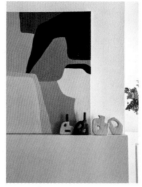

P. 18: Julie Lansom, *Forest in the Springtime*; Géraldine de Zuchowicz, *Sculptures and Candlesticks*. Photo © Nicolas Matheus, in the residence of interior architect Constance Laurand.

P. 21: Audrey Noël, *Untitled*; Jean-Charles Yaïch, *Kirigami 414*; Benjamin Didier, *Continuum No. 14*; Marjolaine de La Chapelle, *Untitled (Large Yellow and Black)* (details). Photos © Hervé Goluza.

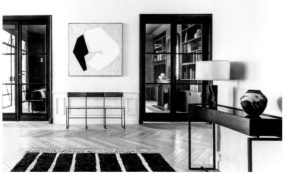

Pp. 22–23: Audrey Noël, *Untitled (Black and White)*. Photo © Sophie Lloyd for the interior architect Caroline Andréoni.

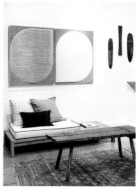

P. 27: Fernando Daza, *Yellow and White Forms*; Agnès Nivot, *Shields*. Photo © Hervé Goluza.

 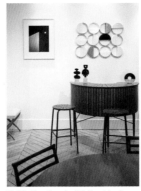

P. 28: Laurent Karagueuzian, *Stripped Papers* (detail). Photo © Hervé Goluza.

P. 36: Benjamin Didier, *Various from Greece, No. 5*; Vanska Seasons, *Loops Pattern*; Amélie Dauteur, *Kodomo* and *Niji*. Photo © Andrane de Barry.

P. 39: Invincible Été, *Wildflowers*. Photo © Frédéric Baron-Morin.

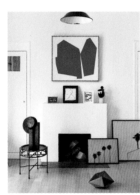 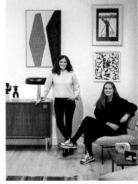

P. 41: Audrey Noël, *Untitled (Cobalt Blue)*; Michaël Schouflikir, *Aegean*; Jean-Charles Yaïch, *Kirigami 416*; Laurent Karagueuzian, *Stripped Papers No. 247*; Amélie Dauteur, *Boshi*; Patricia Zieseniss, *Friend*; Hubert Jouzeau, *Palm Trees*; Danielle Lescot, *Large Reef*. Photo © Hervé Goluza.

P. 42: Amélie Dauteur, *Happi* and *Otoko*; Marc Beaudeau Dutilleul, *Diptych*; Hervé de Mestier, *The Lake, Elle*; Laurent Karagueuzian, *Stripped Papers No. 231*; Géraldine de Zuchowicz, *Berlin*; Agnès Nivot, *Cube Collection 11*. Photo © Andrane de Barry.

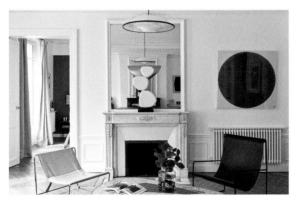

Pp. 44–45: Amélie Dauteur, *Dansa* and *Iwa*; Fernando Daza, *Raspberry Circle*; Géraldine de Zuchowicz, *Bogota*; Michaël Schouflikir, *Uproar*. Photo © Hervé Goluza.

P. 47: Audrey Noël, *Untitled (Blue, Orange, Black, and Yellow)* (detail). Photo © Hervé Goluza.

List of works

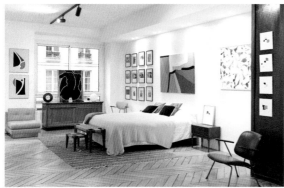

Pp. 48–49: Kanica, *Malbec Composition* and *Blue Composition*; Agnès Nivot, *Brown-Black Striped Ring*; Anne Brun, *Gilded Flowers*; Géraldine de Zuchowicz, *Venice*; Jean-Charles Yaïch, *Nude from the Back*; Danielle Lescot, *Little Ball with Matte Blue Facets*; Lumière des Roses, collection of vintage photographs; Julie Lansom, *Camargue*; Laurent Karagueuzian, *Stripped Papers No. 302*; Marie Amédro, *Visible Invisible No. 10*; Claire Borde, *Counterpoints*. Photo © Andrane de Barry.

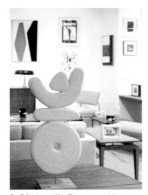

P. 50: Amélie Dauteur, *Kumo*. Photo © Andrane de Barry.

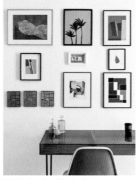

P. 52: Raphaële Anfré, *Femininity Yielding*; Hubert Jouzeau, *Palm Trees*; Marie Amédro, *Synergies*; Milena Cavalan, *Zebrina*; Baptiste Penin, *Sri Lanka*; Pascaline Sauzay, *Imaginary Variation*; Marjolaine de La Chapelle, *Untitled*. Photo © Hervé Goluza.

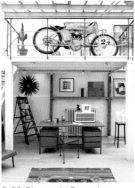

P. 55: Plume de Panache, *Peipou*; Lucia Volentieri, *Tridi*; Michaël Schouflikir, *Japan* and *Trick*; Danielle Lescot, *Pyramid*, *Cube*, and *Tower*; Mise en Lumière, *Portobello*, *London*; Amélie Dauteur, *Little Daburu*; Marion Pillet, *Sunset*; Marjolaine de La Chapelle, *Untitled (Medium Yellow Blue Square)*; Audrey Noël, *Collage*; Patricia Zieseniss, *Double Me*. Photo © Hervé Goluza.

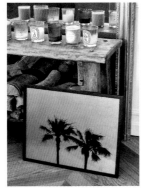

P. 56: Hubert Jouzeau, *Palm Trees*. Photo © Hervé Goluza.

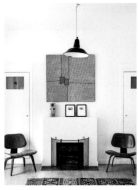

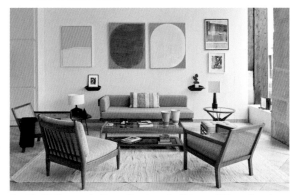

P. 59: Marjolaine de La Chapelle, *Untitled (Yellow 3)*; Gabi Wagner, *Untitled*. Photo © Hervé Goluza.

Pp. 60–61: Fernando Daza, *Two Inverted Forms*; Milena Cavalan, *Focus*; Bernard Gortais, *Continuum*; Danielle Lescot, *Pyramid*; Agnès Nivot, *Cube Collection*; Eliane Pouhaër, *New York*; Amélie Dauteur, *Kozo*. Photo © Hervé Goluza.

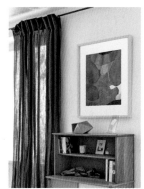

P. 62: Lucia Volentieri, *Quatro Cerchi*. Photo © Hervé Goluza.

P. 64: Raphaële Anfré, *Femininity in Repose No. 5*; Danielle Lescot, *Medium Reef*; Anne Brun, *Gingko* and *Sea Urchin*; Patricia Zieseniss, *Rest*. Photo © Hervé Goluza.

P. 67: Baptiste Penin, *Santorini* (detail). Photo © Hervé Goluza.

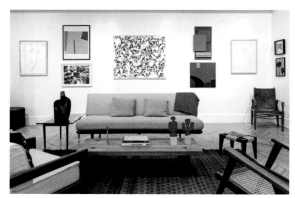

Pp. 68–69: Jean-Charles Yaïch, *Kirigamis*; Joël Froment, *Untitled (Red, Green, and Beige)*; Raphaële Anfré, *Intimacy of a Femininity No. 3*; Laurent Karagueuzian, *Stripped Papers No. 288*; Marc Beaudeau Dutilleul, *Relief 3*; Marjolaine de La Chapelle, *Untitled (Blue Yellow Rectangle)*; Milena Cavalan, *Firmament*; Hubert Jouzeau, *Palm Trees*; Patricia Zieseniss, *Submission*; Amélie Dauteur, *Onna* and *Happi*; Biombo, *Stool*. Photo © Andrane de Barry.

List of works

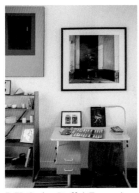

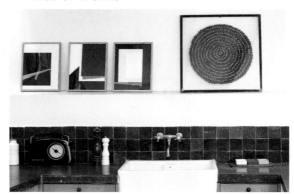

P. 71: Carlos Stoffel, *Turquoise*; Thibault de Puyfontaine, *Hole of Light*; Emma Iks, *Martini*; Anne-Laure Maison, *House-Woman on the March*. Photo © Appear Here.

Pp. 72–73: Marie Amédro, *Triptych Combination*; Plume de Panache, *Lugano*. Photo © Hervé Goluza.

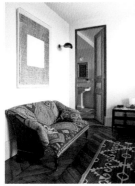

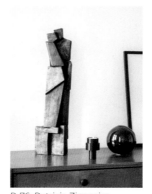

P. 74: Fernando Daza, *White Square Beige Ground*. Photo © The Socialite Family, Valerio Geraci, Constance Gennari.

P. 76: Patricia Zieseniss, *Couple II*. Photo © The Socialite Family, Valerio Geraci, Constance Gennari.

P. 79: Marion Pillet, *Blush*. © Marion Pillet.

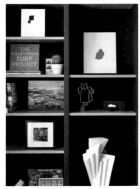

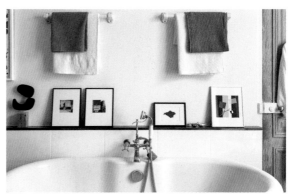

P. 80: Claire Borde, *Counterpoint No. 3*; Baptiste Penin, *Mauritius*; Lucia Volentieri, *Tridi*; Agnès Nivot, *4 Cube Collections*; Mise en Lumière, *Jim Morrison, Venice Beach*; Patricia Zieseniss, *Thank You*. Photo © Hervé Goluza.

Pp. 82–83: Amélie Dauteur, *Baransu*; Pascaline Sauzay, *Imaginary Variations*; Baptiste Penin, *Isle of Wight*; Lucia Volentieri, *Uccelli*; Joël Froment, *Musical Variation*. Photo © Hervé Goluza.

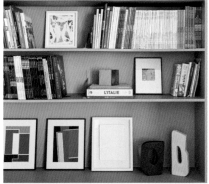

Pp. 84–85: Photos © Hervé Goluza. © Estelle Mahé.

Pp. 86–87: Marie Amédro, *Synergie 14* and *17*; Bernard Gortais, *Continuum 180*; Géraldine de Zuchowicz, *Vienna* and *Grenada*; Danielle Lescot, *Cube*; Pascaline Sauzay, *Imaginary Variation*; Laurent Karagueuzian, *Stripped Papers*. Photo © Hervé Goluza.

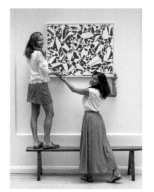
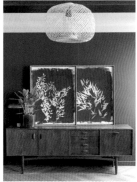
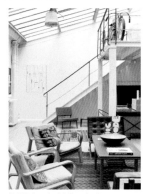

P. 88: Laurent Karagueuzian, *Stripped Papers No. 272.* Photo © Hervé Goluza.

P. 90: Invincible Été, *Wildflowers* and *Bamboo.* Photo © Frédéric Baron-Morin.

P. 92: Lucia Volentieri, *Quatro Cerchi*; Marie Amédro, *Ensemble No. 4*; Amélie Dauteur, *Karimi* and *Tomodashi.* Photo © Hervé Goluza.

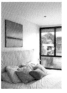

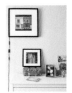
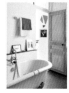

P. 95: Hélène Leroy, *Moors.* Photo © Estelle Mahé. Raphaële Anfré, *Intimacy of a Femininity No. 16*; Géraldine de Zuchowicz, *Vienna* and *Grenada.* Photo © Hervé Goluza. Mise en Lumière, *Portobello, London*; Thibault de Puyfontaine, *Triangle*; Michaël Schouflikir, *Play.* Photo © Hervé Goluza. Baptiste Penin, *Isle of Wight*; Lucia Volentieri, *Uccelli*; Joël Froment, *Musical Variation* and *Dynamic Construction*; Danielle Lescot, *Triangles.* Photo © Hervé Goluza.

List of works

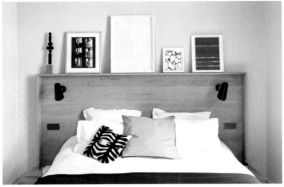

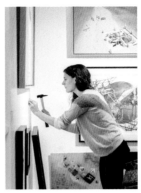

Pp. 96–97: Amélie Dauteur, *Black Kiru*; Hervé de Mestier, *Boa Contact Sheet, Elle*; Marion Pillet, *White and Gold I*; Laurent Karagueuzian, *Stripped Papers No. 225*; Bernard Gortais, *Continuum 153*. Photo © Hervé Goluza.

P. 98: Michel Cam and Anne-Laure Maison, visuals from the *Human Soul* project. © Photo Appear Here.

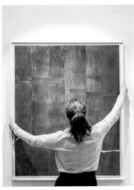

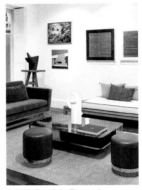

P. 101: Bernard Gortais, *Continuum 5*. Photo © Appear Here.

P. 102: Fernando Daza, *Beige Circle*. Photo © Fernando Daza. Audrey Noël, *Untitled (Blue)*. Photo © Wilo & Grove.

P. 105: Patricia Zieseniss, *Double Me* and *Friend*; Gilles de Fayet, *Taroko Gorges of Taiwan*; Pascaline Sauzay, *Imaginary Painting III*; Fernando Daza, *Black and White Square Structure on a Blue Ground*. Photo © Hervé Goluza.

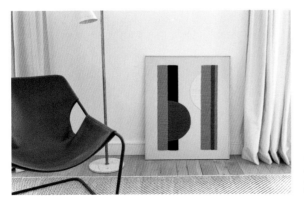

P. 106: Kanica, *Untitled (Large Rust-Colored, Pink, and Black Version)*. Photo © Hervé Goluza.

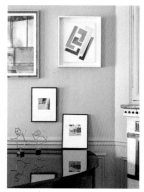

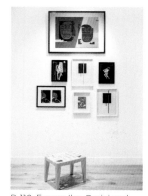

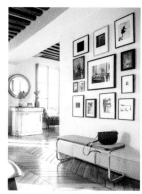

P. 108: Éliane Pouhaër, *Madrid II*; Joël Froment, *Musical Scale*; Lucia Volentieri, *Piro* and *Etta*; Pascaline Sauzay, *Imaginary Variations Nos. 12* and *11*. Photo © Hervé Goluza.

P. 110: Emma Iks, *Goriyi* and *Back to the Future*; Anne-Laure Maison, *House-Woman Black Sun* and *House-Woman in a Hat*; Carlos Stoffel, *Untitled (White Ground Brown Square)* and *Untitled (White Ground Blue Square)*; Bernard Gortais, *Chanceful Arrangement 66*; Biombo, *Stool*. Photo © Appear Here.

P. 111: Lumière des Roses, collection of vintage photos; Thibault de Puyfontaine, *Collodion Portrait*. Photo © The Socialite Family, Valerio Geraci, Constance Gennari.

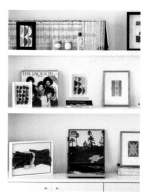

P. 112: Michaël Schouflikir, *The Waves*, *Crowd*, and *Well Packed*; Margaux Derhy, *Gate of the Anti-Atlas Nos. 10* and *17*; Raquel Levy, *Red and Yellow Creased Papers*. Photo © Hervé Goluza.

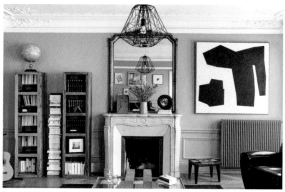

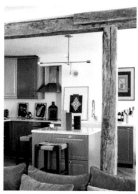

Pp. 114–15: Audrey Noël, *Untitled*; Agnès Nivot, *Collections*, *Staircases*, and *Rings*; Danielle Lescot, *Reef*; Hervé and Sophie de Mestier, *Brought to Light*; Joël Froment, *Musical Scale*; Eliane Pouhaër, *Madrid*; Baptiste Penin, *Réunion*; Biombo, *Stool*. Photo © Hervé Goluza.

P. 116: Invincible Été, *Carrot Flowers* and *Ferns*; Margaux Derhy, *Gate of the Anti-Atlas (Green and Purple)*; Danielle Lescot, *Vases*; Biombo, *Bar Stools*; Carlos Stoffel, *Pink and Bordeaux*. Photo © Hervé Goluza.

List of works

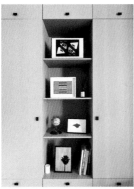

P. 119: Milena Cavalan,
Conversation, Still Life;
Joël Froment, *Horizontals*;
Baptiste Penin, *Isle of Wight*;
Hubert Jouzeau, *Palm Trees*.
Photo © Hervé Goluza.

P. 120: Jean-Charles Yaïch,
Untitled. Photo © Hervé
Goluza.

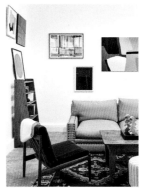

P. 123: Audrey Noël, *Untitled*;
Marjolaine de La Chapelle,
Medium Blue; Éliane Pouhaër,
Madrid III; Carlos Stoffel,
Untitled (Purple Orange Bar);
Julie Lansom, *The Forest III*;
Lucia Volentieri, *Due Moduli*.
Photo © Hervé Goluza.

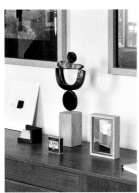

P. 124: Claire Borde,
Counterpoint No. 6; Agnès
Nivot, *Tablet Collection*;
Amélie Dauteur, *Torofi*;
Michaël Schouflikir, *Trick*.
Photo © Hervé Goluza.

P. 126: Bernard Gortais, *Continuum 161* (detail). Photo © Hervé
Goluza.

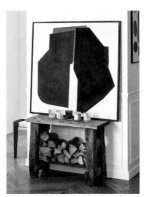

P. 131: Audrey Noël, *Untitled
(Three Forms)*. Photo © Hervé
Goluza.

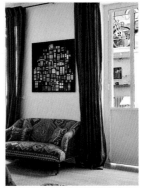

P. 142: Anne-Laure Maison,
*House of Secrets, Aix-en-
Provence*. Photo © Hervé
Goluza.

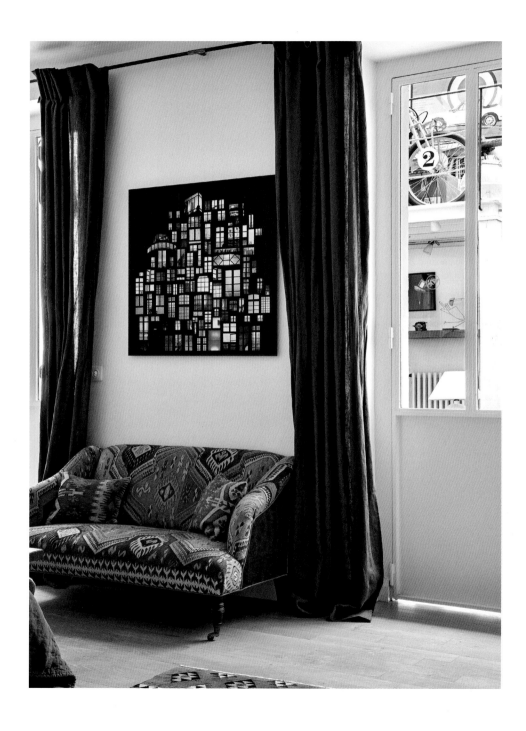

Acknowledgments

We wish to express our wholehearted thanks to:

· Our husbands, who have always been at our side and steadfastly remain there, despite everything we've put them through since we launched Wilo & Grove (or in any case, they were at the time this book went to press!).

· Our families, who have supported us since the beginning of our adventure with patience, kindness, and enthusiasm, but who have frequently challenged us, too.

· Our friends, who have advised, helped, prodded, listened to us with open minds, and offered intelligent insights (sometimes over a glass of wine or two); who pounded nails, lugged boxes, repainted walls, and cut out exhibition labels by the hundreds, before we had our wonderful team to assist us.

· Our fabulous team, without whom this machine wouldn't run smoothly each day. They bring even more meaning to our entrepreneurial roller coaster.

· Our artists, without whom Wilo & Grove simply wouldn't exist. They add sparkle to our lives every day with their talent and creativity, and we are honored that they have placed their trust in us.

· All of our clients—our "Wilovers"—to whom we dedicate this book. We particularly thank our early supporters (they know who they are), the "repeat offenders" whose loyalty never fails to move us, and all the newcomers who enter Wilo & Grove uttering the most beautiful sentence in the world: "I've never set foot in a gallery before."

· A special thank-you goes to our former interns and the many partners who have given us their all ever since the early days (@ Big Cheese, Estellum, and Agence Mews).

· "La Fitho," who helped us turn the corner and agreed to be chairman of our board (even if he didn't have much choice in the matter!).

· Virginie Maubourguet, Mathilde Jouret, Marie Vendittelli, Kate Mascaro, and Helen Adedotun, who accompanied us in the creation of this book with professionalism, good humor, and kindness.

· All those who have entrusted us with inspiring projects: L'Agence Varenne, Le Bon Marché, La Brocante La Bruyère, Brunswick Art, Caravane, La Chance, Les Galeries Lafayette Maison, Merci Paris, Red Edition, and The Socialite Family.